Classical Art Sculpture

To Wright S. Ludington

Classical Art Sculpture

by Mario A. Del Chiaro

with an additional contribution by

Andrew F. Stewart

Santa Barbara Museum of Art

Cover: 12. Aphrodite (Nymph), marble

Published by the Santa Barbara Museum of Art
1130 State Street
Santa Barbara, California 93101

Copyright © Santa Barbara Museum of Art

All rights reserved
Printed in the U.S.A.

Designed by COY, Los Angeles

All catalogue entries and colorplates
© James Chen Studios, Santa Barbara

All comparative photographs by Wayne McCall

Colorplate no. 32, Schopplein Studio

Text was set in Linotype Aldus by Central
Typesetting Company, Los Angeles

Printed in an edition of 5,000 by
Alan Lithograph, Inc., Los Angeles

Map drawn by Martha Breen Bredemeyer

Library of Congress Cataloging in Publication Data

Del Chiaro, Mario Aldo, 1925-
 Classical art at the Santa Barbara Museum of Art.

 1. Sculpture, Classical—Catalogs. 2. Sculpture—
California—Santa Barbara—Catalogs. 3. Santa Barbara
Museum of Art—Catalogs. I. Santa Barbara Museum of Art.
II. Title.
NB87.S26S264 1984 733'.074'019491 84-23651
ISBN 0-89951-055-8

Table of Contents

Foreword

6

How does one define the enduring satisfaction of the art of classical antiquity? In the third century, Egyptian-born Roman philosopher Plotinus put it this way: "the symmetry of the parts towards one another and towards the whole, with, besides, a certain charm of color, constitutes the beauty recognized by the eye . . . in visible things, as indeed in all else, universally, the beautiful thing is essentially symmetrical, patterned" (*Enneads*, I, 6, I, translation by S. MacKenna).

With the exception, alas, of the "certain charm of color" which time has almost entirely erased from marble and limestone surfaces, the classical sculpture in the Wright S. Ludington collection surely fits this definition of beauty. The symmetry and easy balance so admired by Plotinos are evident to some degree in every piece upon careful viewing, a pleasure which we hope this catalogue will enhance with knowledge.

Many of the examples of classical sculpture described in this catalogue have been on constant display at the Museum almost from the day it first opened its doors. Thus, for a period of over four decades as this is written, visitors to the Museum have been privileged to enjoy the benefits of Wright Ludington's sensitivity and acumen as a collector. *In toto*, including promised gifts, the Ludington collection is one of the finest of its kind in the country. We hope that this catalogue will complement Mr. Ludington's public-spirited generosity by making the collection better known to a wide circle of scholars and art lovers.

We are grateful to Dr. Mario A. Del Chiaro, Professor of Art History, University of California, Santa Barbara, for initiating and carrying through the long-awaited research into the various pieces constituting the Ludington collection. Professor Del Chiaro has carefully and patiently investigated the sculptures over a period of several years, and this volume is as much a monument to his scholarship and perseverance as it is a tribute to the generosity and perception of Wright S. Ludington.

We are most appreciative of the additional essay written for this catalogue by Dr. Andrew F. Stewart, Professor of Art History, University of California, Berkeley. Ariel Herrmann deserves our appreciation as well, for the entry for catalogue number 8.

The curatorial staff of the museum, both past and present, and former Director Paul Chadbourne Mills deserve our gratitude for initiating this most worthwhile project. Chief Curator Robert Henning, Jr. has expertly overseen the compilation and editing of manuscripts and the final form the text has taken, while Assistant Director for Publications and Programs Shelley Ruston shepherded the catalogue through all stages of production. Finally, and in the best classical tradition, John and Margaret Coy have designed a publication in which form and content are elegantly united.

Richard Vincent West
Director

Acknowledgments

It is a common human tendency to seek our roots — cultural as well as genealogical — and to turn to the past for an explanation of the present nature of things. The basis for much of Western aesthetic theory as well as a whole vocabulary of artistic types and standards have been derived from the achievements of ancient Greece and Rome. In the form of rebirths, revivals, rediscoveries, the great works of classical artists and architects have inspired the art of succeeding generations from the Italian Renaissance to the present day.

While America was a fledgling country, English gentlemen scoured the archaeological sites of the ancient world to embellish their stately homes, many constructed in the latest "classical" style; the artifacts they acquired are now the basis of many European museum collections. For centuries ancient sites were ransacked and their contents dispersed. By the time American museums came into being, early in this century, the broad scale collecting of antiquities — by legitimate or other means — was not so easy. Despite the neoclassical aspirations of our founding fathers and the efforts of some collectors and museums, few American institutions have been able to form important collections of classical antiquities of a quality comparable to their other holdings.

Thus, the Santa Barbara Museum of Art is especially fortunate to have received the outstanding collection of classical sculpture here catalogued — only one part of the generous gifts of Wright S. Ludington which date from the founding of the museum to the future promised gifts included in the final addendum. This collection, as the following catalogue makes clear, is the achievement of a man of remarkable taste, unusual vision, and exemplary generosity. Mr. Ludington's legacy assures in a significant way the survival of antiquity for future generations of museum-goers to discover in their own manner something of the important heritage of Greece and Rome.

This catalogue was first conceived under the curatorship of my predecessor, the late Katherine Harper Mead. Since that time, a number of changes have modified its conception: new works have entered the collection, new information has been discovered, the scale of the publication has expanded. Special credit must go to former Director, Paul Chadbourne Mills, whose choice of Mario Del Chiaro as author and James Chen as photographer assured us of a catalogue with sound scholarship and visual appeal appropriate to the objects it records. Throughout the project, Mr. Ludington's encouragement and kind advice have been of great help. The author, Mario Del Chiaro, has shown patience and concern over every aspect of the preparation of this catalogue. Assistant Curator for Collections, Barry M. Heisler, has patiently overseen the countless details to assure the accuracy and smooth production of this complex project as it grew in scope and content. Curatorial Assistant, Ethel King, brought special skills and a discerning eye to the final stages of production and, along with Museum Designer, Rick Hubbard, developed the map which accompanies the text. Carol Leyba provided a final editorial review of the various elements that make up the final form of this catalogue. Shelley Ruston, Assistant Director for Publications and Programs and Judyl Mudfoot also supplied important editorial assistance as did Shirley Taylor who worked on earlier stages of the publication. I would like to add a note of appreciation to that of the author for the research and advice provided by various graduate students and consultants named throughout the catalogue.

Robert Henning, Jr.
Chief Curator

Preface

Our knowledge of the ancient Greeks, our appreciation and understanding of their art, and our awareness of their special role in the history of Western culture are based on what we see as well as on what we read. Therefore we are indeed fortunate to have available for public view in Santa Barbara a noteworthy collection of Greek sculpture, bronzes, and painted vases. Although the collection is a small one and not fully representative of an unbroken evolutionary sequence, it offers a more than merely adequate glimpse into the artistic achievement of these vital and influential people of the past. For general viewers as well as students, the collection is invaluable.

Even in a fragmentary state, Greek sculpture can convey to the modern viewer some of its original beauty or symbolic meaning. As we try to reconstruct the original appearance of a statue on the basis of what remains, we begin to comprehend the part that sculpture played in the history of a past civilization, and we gradually are able to visualize these fragments not as mere relics of the past — perhaps meaningless and cold to some — but as testimonials to the variety, spontaneity, versatility, and freedom of the individualistic character ever present in the art of ancient Greece.

That a community the size of Santa Barbara may justly boast an impressive collection of classical antiquities is due in large part to the taste and generosity of one of the chief benefactors of the Santa Barbara Museum of Art, Wright S. Ludington, collector and longtime resident of this lovely city between the mountains and the sea. Our debt to him, obviously, is enormous. I am grateful to Paul Chadbourne Mills, former Director, and the late Katherine H. Mead, former Curator of Collections, as well as the present Director and staff for their kind permission to study the collection of classical antiquities and to publish the results in this catalogue. I must also acknowledge a number of students in my graduate seminars whose diligent and astute research has been incorporated into the separate entries of the catalogue: Faya Causey Frel (nos. 1, 6, 13, 15, and 17), Anne Edgerton (nos. 3, 10, 11, and 12), Georgia Lee (nos. 7, 9, and 18), and Julie McKemy (nos. 4, 5, 16, 19, and 20). On a number of occasions, I have been able to avail myself of the expert opinions and reflections of visiting colleagues: Dr. Frank Brommer, Dr. Jirí Frel, Dr. Evelyn Harrison, and Dr. Brunilde Sismondo Ridgway. I am grateful for their comments, but they are in no way to be held responsible for any shortcoming or controversial conclusions that may occur in the text.

M.D.C.

Introduction

In the remarkable civilization of ancient Greece, art was more than the preoccupation of artists and connoisseurs. Probably more than in any other civilization, the citizens of the Greek *polis* (city-state) were qualified by their individuality, aspirations, and experience, to judge and support the creations of their artists and craftsmen. Artists and craftsmen were aware of their civic duties and had a strong sense of responsibility toward the community. Within the bounds of numerous religious, social, and artistic conventions, the architects, sculptors, painters, and other artisans never failed to instill a personal vision into their work. Their goal was not to be original but rather to *excel*; that is, to improve on the work of their predecessors or contemporaries. In essence, this goal echoed the desire of every Greek citizen to excel in all virtues.

The ancient Greek regarded Man as the center of all things. Man was not made in the image of the gods: the gods presented the image of Man; they had all Man's virtues and vices. This view of Man is reflected in the concern of the Greeks for the accurate and sensitive representation of the human form and in the search for beauty. Whereas the ancient Egyptian representation of the human form remained essentially unchanged throughout the millennia of Egyptian history, in Greece, within the relatively short span of less than four centuries — from the Archaic period through the Classical era into Hellenistic times — the representation of the human form evolved with startling rapidity from a rather stiff hieratic pose to one of convincing naturalism.

One must not forget that ancient Greece was never a single, unified nation, not even during the period of Alexander the Great. In modern Greece there is still a lingering sense of one's belonging primarily to a place or city — to a polis — so that people identify themselves as "Athenian," or "Spartan," for example, not simply as Greek. In ancient times, the loyalty to a polis was often accentuated by the geographic and topographic isolation of a community or area. In many cases this kind of isolation had much to do with the development of the regional styles in art that we describe as Attic, Argive, East Greek, and so on. In spite of these differences, Greek art acquired a homogeneity that distinguishes it from the art of any other civilization. This was due in large measure to the superiority of Athens and to its vast and universally admired sculptural programs such as the sanctuaries, including temples and cult statues, created by the great architects and sculptors and their workshops. Of all the city-states, Athens was the one destined to attain a special level of accomplishment, and the content and originality of Athenian artistic and cultural achievement were unrivaled.

The Archaic period of Greek art, lasting roughly from the late seventh to the early fifth century B.C., was the beginning of the Greek understanding of the human form. There had been a long "Dark Age" following the Dorian invasions that brought down the flourishing Mycenaean civilization around 1100 B.C. From the seventh century onward, the Hellenic civilization made great strides in political development and in all branches of art and architecture. In sculpture, the depiction of the human form evolved gradually in these two centuries from stiff figures, reminiscent of Egyptian prototypes in their simplicity and squareness, to the later *kouroi* (nude youths), which, though still conventionalized, show an increasingly perceptive appreciation of human anatomy and skill in rendering. The Santa Barbara Museum of Art has recently acquired an example of Greek sculpture of the Archaic period (no. 2) which, together with the Cypriot head (no. 1) dating from the second half of the sixth century B.C, are admirable illustrations of the sculptural characteristics of the Archaic period. The hair is conventionalized, while the modeling of the nose and cheekbones conveys a certain naturalness of expression.

In the Classical period, the fifth and fourth centuries B.C., the striving for perfection in rendering the human form, both male and female, continued and reached its peak in the work of the great masters, Myron, Pheidias, and Polykleitos in the fifth century, and Skopas, Praxiteles, and Lysippos in the fourth century. Because nearly all original work of these masters has been lost, our knowledge of them comes primarily from literary references, as in Pliny and Pausanias, and from the many copies and versions of the originals that were produced in later, chiefly Roman, times. Though we may regret the loss of the originals, we are thankful that the Romans were not unsympathetic to the art and culture of the Greeks whom they conquered. The Roman legions bore the statuary and other works of portable art back to Rome, and Romans soon developed an insatiable appetite for Greek art to adorn their palaces and villas. The result was a wholesale copying of Greek statues, many of which would otherwise now be only names recorded by Greek and Roman writers.

In execution, these copies range from bad to good. To be successful, a copyist must have not only technical ability but also some comprehension of the inspiration behind the original work. In many instances, the copies that have come down to us were made by Greek craftsmen during Roman times in an environment akin to that of the original works — hence the convenient term "Graeco-Roman." If such craftsmen were particularly gifted, their

versions evoke some of the spirit and quality of the original. In other instances, one senses a lack of inspiration and grasp of the subtleties of the original. In addition, there may be a certain mechanical inaccuracy, ill-chosen changes in pose and gesture, and a total lack of life and power. Often one must simply disregard the Roman additions and modifications in order to gain some notion of the original Greek forms — or else accept the copies on their own merit as more or less interesting examples of changing tastes in Roman art and fashions.

Three statues in the Santa Barbara collection are of importance in illustrating something of the style of the Classical period of the fifth century B.C. and of the work of two of the great masters, Pheidias and Polykleitos. The Peplophoros (no. 3) is a good example of the so-called Severe Style current in the early Classical period (about 480–450 B.C.). The long, heavy lines of the peplos and the dignity of the pose still show traces of the late Archaic style, but the extended foot conveys an incipient sense of movement. The Santa Barbara Athena (no. 4) continues the development. Here, one senses beyond doubt that there is a body, a rounded form, beneath the flowing lines of the drapery. This statue, though far removed from Pheidias in date of execution, is ultimately derived from the great gold and ivory cult statue of Athena that that artist created for the cella (or naos) of the Parthenon. Under Pericles, from 447 B.C. for a period of some fifteen years, Athens undertook a vast building program to restore and enhance the Akropolis after damage inflicted during the Persian wars. The Athenian sculptor Pheidias was appointed chief overseer of all artistic undertakings. His huge statue of Athena became the prototype of many statues of the goddess. The Santa Barbara Doryphoros (no. 5), though fragmentary, ranks among the best of the surviving copies of the much-admired Doryphoros by the sculptor Polykleitos of Argos. Polykleitos was known chiefly for his skill in portraying athletes, and this statue is a fine illustration of his rendering of the well-muscled male anatomy — idealized and somewhat hard in surface character, yet natural.

During the course of the fourth century B.C., the surface character of the sharply defined and somewhat tense muscles of fifth-century sculpture began to soften, showing increased knowledge of anatomical structure — of muscle and flesh. In sculpture of all types, there was an increasing refinement (cf. nos. 5, 7, and 18). This change is epitomized by the male figures of Praxiteles, such as his Hermes and the Infant Dionysos (at Olympia) and the Apollo Sauroktonos (fig. 6). Praxiteles must also be credited with having inspired the long line of nude or partially nude sculptures

of Aphrodite (Venus; see nos. 12–15), which are derived from his celebrated statues of the goddess purchased by the citizens of Kos and Knidos (cf. fig. 11; Pliny, *Natural History*, 36.20). The work of Lysippos, a fourth-century sculptor who exerted as much influence on Roman art as the fifth-century Polykleitos, is represented in the Santa Barbara collection by the torso of Herakles (no. 9); and the youthful head (no. 6), with the fleshy forehead, deep-set eyes, and parted mouth, embodies known characteristics of the work of Skopas. Rewarding comparisons may be made between the Cypriot head (no. 1), the Archaistic head (no. 17), and the Skopaic head (no. 6) to appreciate the changes that took place in the representations of heads in the four centuries from the Archaic period to the beginning of the Hellenistic period. In the Archaic Cypriot head, the hair and beard are highly stylized, with snail curls and close ringlets, and the eyes are almond-shaped. The Archaistic head (no. 17) must here serve for fifth-century Classical forms in which the brows are flat planes and noses are sharply chiseled. In the fourth century B.C. the head acquired a distinctly natural appearance, and the conspicuous bulge of flesh at the forehead just above the bridge of the nose (no. 6) became a popular detail of physiognomy.

During the Hellenistic period (323–330 B.C.), which followed the conquests of Alexander the Great, the establishment of new trade centers and trade routes throughout the Near and Middle East was a great stimulus to art and architecture, and Classical forms were widely circulated and imitated. Thanks to the patronage of cultured and enlightened rulers, impressive new centers of art began to flourish at places like Pergamon, Alexandria, and Rhodes; their productions were to become a legacy of Rome. Athens, though it never regained its former political stature following the defeat by Sparta and its allies at the close of the Peloponnesian War (431–404 B.C.), remained the spiritual and cultural center of the Classical world through Hellenistic and, to a degree, Roman times.

For the artist as for the scientist, the Hellenistic period was a time of search and inquiry. In sculpture, the human form was still the most popular subject, but poses and gestures were more zestful and vigorous than before; the rendering of anatomy often went beyond mere naturalism, as in the well-known Suicidal Gaul and the Laocoön. There was a great deal of experimentation with new types, including the grotesque and the ugly, along with a relative neglect of the major Olympian deities who had been so consistently portrayed by the masters of the Archaic and Classical periods. Sensual deities, such as Aphrodite and her offspring Eros, became increasingly popular (see nos. 12–15),

and the formerly virile Hermes (Mercury) and Dionysos (Bacchus) declined into little more than effeminate youths. There was a challenge in the exotic ethnic types (the invading and conquered Gauls or Galatians) and in ordinary men and women engaged in mundane pursuits. Hermaphrodites, dwarfs, hunchbacks, and the like — subjects never before regarded as suitable or worthy subjects for sculpture — appear with surprising frequency. Erotic and sensual themes, generally restricted to vase painting in the Archaic and Classical periods, became common in monumental sculpture, and were frequently seen in groups of frolicking satyrs, nymphs, and maenads (female votaries of Dionysos) (no. 16).

Generally, although present-day taste may vary, the art of the Hellenistic period, including the sculpture that imitates earlier types, cannot be said to have declined technically or aesthetically. The Greek exploration of beauty in the human form continued, but with an increased emphasis on naturalism rather than on idealized reality. This is evident in the Hellenistic period not only in the contrast of flesh and drapery but often in the concern for the texture of drapery; for example, sculptors tried to render the lightness and transparency of the linen *chiton* and the coarser, heavy quality of the woolen *himation* mantle (as in no. 11). Most significant was the interest in drapery for the sake of the sculptural excitement of rich, complex, and rhythmic patterns of folds and the resulting play of light and dark (nos. 10–12).

The changes in the treatment of drapery in sculpture are only some of the many details that can be studied in the objects on view in the Classical collection of the Santa Barbara Museum. This introduction is by necessity a brief guide to looking. The descriptions of the objects in the numbered entries point out additional details and parallels that will perhaps suggest to viewers a *way* of seeing and act as a stimulus to further study and viewing of Greek art.

Some of the Classical sculptures and painted vases in the Santa Barbara Museum of Art collection have been included in earlier, tentative studies.* Some of the material dealing with the sculpture has been revised and updated for the present catalogue.

Although the majority of the stone sculptures in the museum are antique copies, the individual statues are listed in approximate chronological order according to the generally accepted dates for the originals or prototypes. For the most part, the visitor may, with catalogue in hand, progress from one sculpture to another according to the consecutive numbering in the catalogue, which conforms to the evolutionary sequence of Greek art outlined in the introduction.

M.D.C.

*See M. Del Chiaro, "Greek and Roman Sculpture in Santa Barbara," *Classical Journal* 60 (1964), pp. 112–121; "Additional Sculpture in Santa Barbara," *Classical Journal* 62 (1967), pp. 170–174; "Classical Vases in the Santa Barbara Museum of Art," *American Journal of Archaeology* 68 (1964), pp. 107–112; and "New Acquisitions of Roman Sculpture at the Santa Barbara Museum of Art," *American Journal of Archaeology* 78 (1974), pp. 68–70.

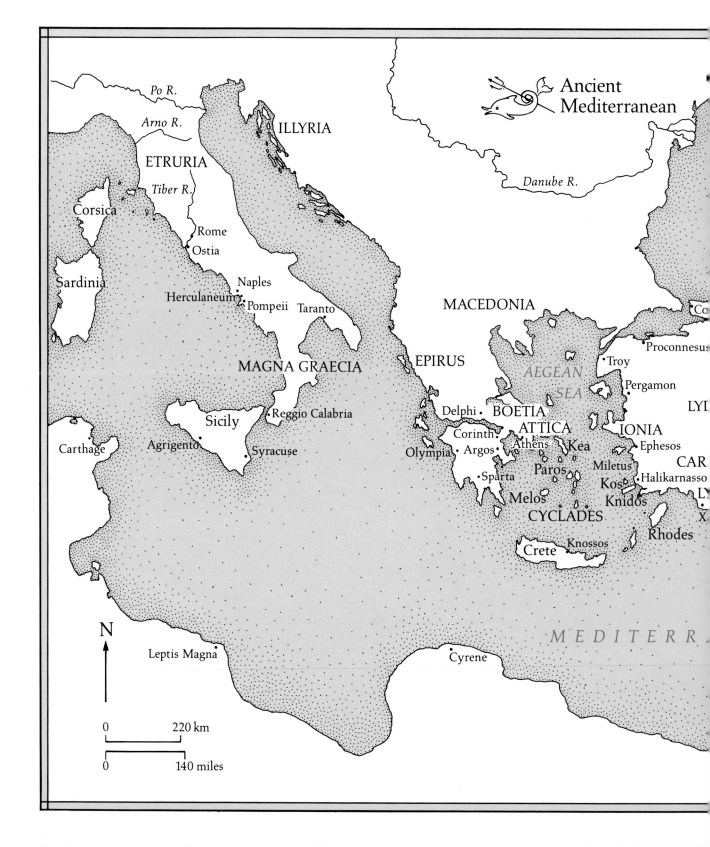

Ancient
Mediterranean

Po R.

Arno R.

ILLYRIA

ETRURIA

Tiber R.

Danube R.

Corsica

Rome

Ostia

Sardinia

Naples

Herculaneum

Pompeii

Taranto

MACEDONIA

Co

Proconnesus

EPIRUS

*AEGEAN
SEA*

Troy

MAGNA GRAECIA

Pergamon

Delphi

BOETIA

LYI

Reggio Calabria

ATTICA

Sicily

Corinth

Athens

IONIA

Olympia

Argos

Kea

Ephesos

CAR

Carthage

Agrigento

Syracuse

Sparta

Paros

Miletus

Halikarnasso

Kos

LY

Melos

Knidos

X

CYCLADES

Rhodes

Crete

Knossos

N

MEDITERR

Leptis Magna

Cyrene

0 220 km

0 140 miles

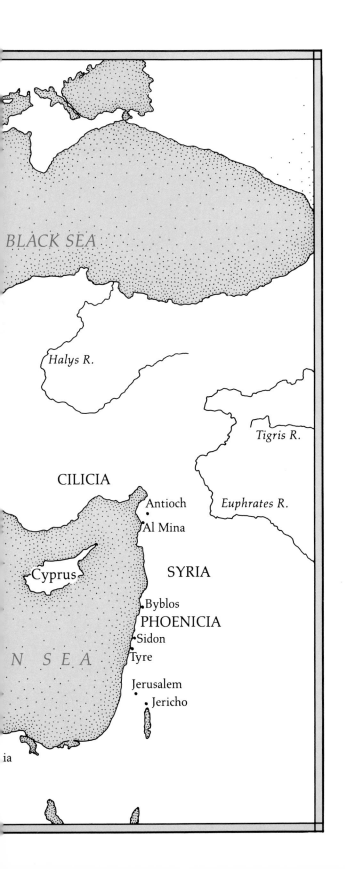

BLACK SEA

Halys R.

Tigris R.

CILICIA

Antioch
•
•Al Mina

Euphrates R.

SYRIA

Cyprus

•Byblos
PHOENICIA
•Sidon
•Tyre

Jerusalem
•
• Jericho

N SEA

ia

1.

Bearded Head
Cypriot. Second half of the 6th century B.C.
1978.4.1
Gift of Wright S. Ludington

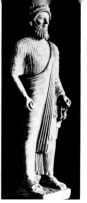

FIG. 1.

14

Although this head conforms to stylistic traits that characterize male and female heads produced during the Archaic period of Greek art, such as almond-shaped eyes, "snail curls" in the beard and hair, and crisp delineation of the mouth, its origin is not Greece but Cyprus, which during the sixth and fifth centuries B.C. evidenced a strong synthesis of Cypriot and Greek elements in art. Now broken at the neck, the head must originally have belonged to a life-sized votive statue of a type common to Cypriot sculpture (see fig. 1).[1] Ordinarily, such limestone sculpture was richly painted, and the iris and pupil, not defined by incised lines, would have been painted in detail.

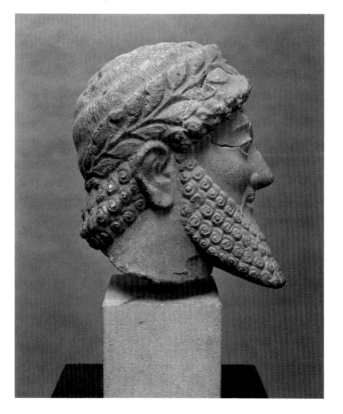

The workmanship of this head is commendable, particularly in the treatment of the tight, conventionalized curls of the beard and the ringlets that outline the forehead and the nape of the neck. The hair radiates downward from the crown of the head and falls in gentle registers of deeply incised wavy strands, which terminate in a double row of tight curls along the forehead and a triple row at the nape of the neck. The looser treatment of these ringlets of the hair and beard contrasts strikingly with the narrow moustache represented by carefully carved rows of small beads. The laurel wreath that encircles the head is simple in its outward form, but the individual leaves are subtly modeled.

Parallels to the Santa Barbara Cypriot head are not difficult to find. Two heads in the British Museum, perhaps slightly later in date than the Santa Barbara specimen to judge from the sharply ridged, rounder eyes, reveal close affinities.[2] Two Cypriot heads in the Metropolitan Museum of Art in New York also offer convincing stylistic parallels.[3] The strongest stylistic analogy may be seen in the head of a statue unearthed at Kition on Cyprus; the modeling of the eyes, ears, nose, and mouth on this head is strikingly similar to the modeling of the features on the Santa Barbara head.[4] According to the stylistic-typological scheme established by Einar Gjerstad for Cypriot sculpture, the Santa Barbara bearded head falls quite suitably into the "second group of the Archaic Cypro-Greek style."[5]

[1] See J. Myres, *Handbook of the Cesnola Collection of Antiquities from Cyprus* (New York, 1914), pp. 215, 216, 219.

[2] F. Pryce, *Catalogue of Sculpture in the Department of Greek and Roman Antiquities of the British Museum,* vol. 2, part 2 (London, 1931), p. 60, figs. 93 (C 151) and 94 (C 152).

[3] New York, Metropolitan Museum of Art, CS 1280 and CS 1290: Myres, pp. 202, 204.

[4] E. Gjerstad, *The Swedish Cyprus Expedition,* vol. 3 (Stockholm, 1937), pl. 15, fig. 2.

[5] *Ibid.,* vol. 4 (Stockholm, 1948), pp. 109–117. A later study has reaffirmed the chronology proposed by Gjerstad; see C. Vermeule, "Cypriot Sculpture, the Late Archaic and Early Classical Periods: Towards a More Precise Understanding, Modification in Concentration, Terms and Dating," *American Journal of Archaeology* 78 (1974), pp. 287–290.

Limestone; warm in tone. No traces of color. Height, 32 cm (approx. 12½ in.).
The head is broken at the neck. A fragment of the right forehead is broken away
but rejoined. Small chips are missing from this fracture along the curls at the
forehead and on the left cheek. Slight abrasions and pitting can be seen at the top
of the head, on the nose, and along the outer edge of the ears.

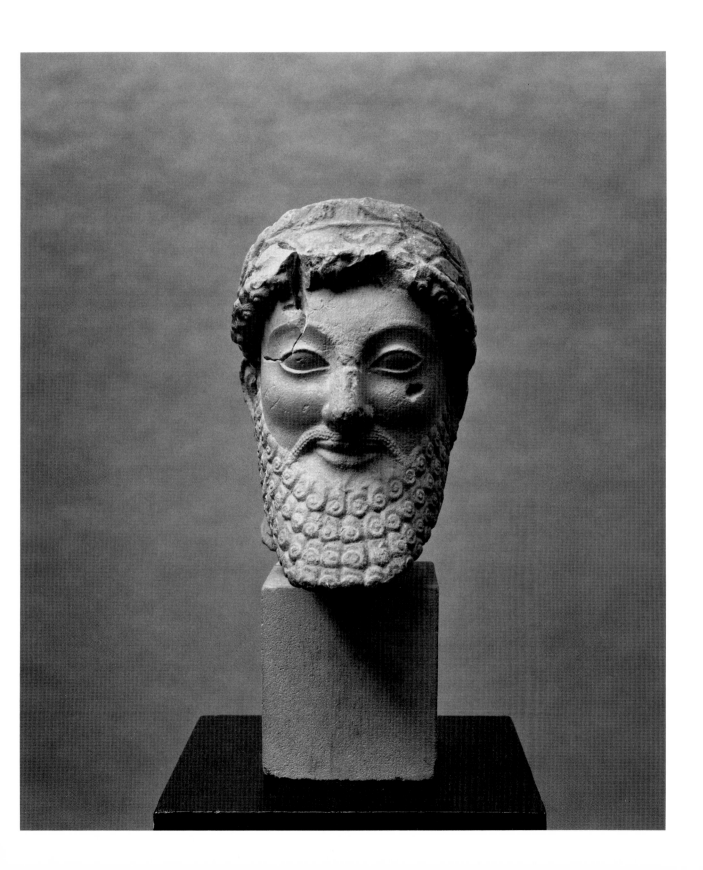

2.

Head of a Youth
Greek (probably Sicilian). End of the 6th century B.C.
1982.66
Gift of Robert M. Light in honor of Wright S. Ludington

In contrast to the material employed for the other sculptures listed in this catalogue — stone but for a single example in bronze — this head is of terracotta, and it must have once belonged to a figure of a youth about three-quarters to half life-size. Crisply modeled and powerful in aspect, the head is an especially fine specimen of coroplastic art chiefly in clay and consequently terracotta — i.e., built up rather than cut or carved away (glyptic). Although terracotta sculpture on a relatively large scale is not unknown for mainland Greece,[1] the most prolific region of coroplastic Greek art is to be found in the western Greek world, namely, southern Italy (Magna Graecia) and Sicily.[2]

In its general physiognomy and hairstyle — unworked at the crown of the head but neatly patterned and delicately rendered elsewhere into long and short strands, the latter terminating in precise, tight snail-curls — the Santa Barbara terracotta youth recalls the heads for *kouroi* of Richter's "Ptoon 20 Group."[3] However, it is to the Greek sculptors of southern Italy and Sicily rather than Greece or areas farther east or southeast that we must turn in order to place this head in its proper artistic climate. Apart from the configuration and treatment of the snail-curls, which bring to mind the terracotta heads from Medma in southern Italy just north of Reggio Calabria (ancient *Rhegion*),[4] details characteristic for heads in stone as well as terracotta may be seen in the elongated, rather slitty eyes with flat eyeballs and very pronounced ridges defining the eyes (eyelids) and eyebrows, and the well-modulated mouth with its full, clearly accented lips.[5]

Of the possible south Italian or Sicilian origin for the handsome Santa Barbara terracotta youth, I prefer the latter — perhaps Agrigento (ancient *Akragas*) — on the evidence of heads attributed to Agrigentine workmanship.[6] If a date is to be given this terracotta head, ca. 500 B.C. would be suitable.

[1]For example, "Zeus and Ganymede" from Olympia: R. Lullies and M. Hirmer, *Greek Sculpture* (New York, 1957), pl. V (color) and pl. 105.

[2]See L. Von Matt and U. Zanotti-Bianco, *Magna Graecia* (New York, 1962); E. Langlotz and M. Hirmer, *Ancient Greek Sculpture of South Italy and Sicily* (New York, 1965); and R. Holloway, *Influences and Styles in the Late Archaic*

and Early Classical Sculpture of Sicily and Magna Graecia (Louvain, 1975).

[3]G. Richter, *Kouroi* (London, 1960), pp. 126ff.

[4]Holloway, figs. 35–38.

[5]Langlotz and Hirmer, pls. 38 and 40.

[6]Holloway, p. 30; see figs. 158, 163, and 165.

Terracotta; reddish brown; very gritty. Preserved height, 18.5 cm (7¼ in.); thickness, 2.5 cm (1 in.).
This hollow sculpture is broken at the neck. The back of the head is missing entirely. Some pitting and chipping can be seen at the tip of the nose, top of the ears, and the chin. A large area is broken and has flaked away from the hair just above the right brow. A creamy colored slip was used for the flesh and extant unfinished surface to the top of the head. There are no traces of paint.

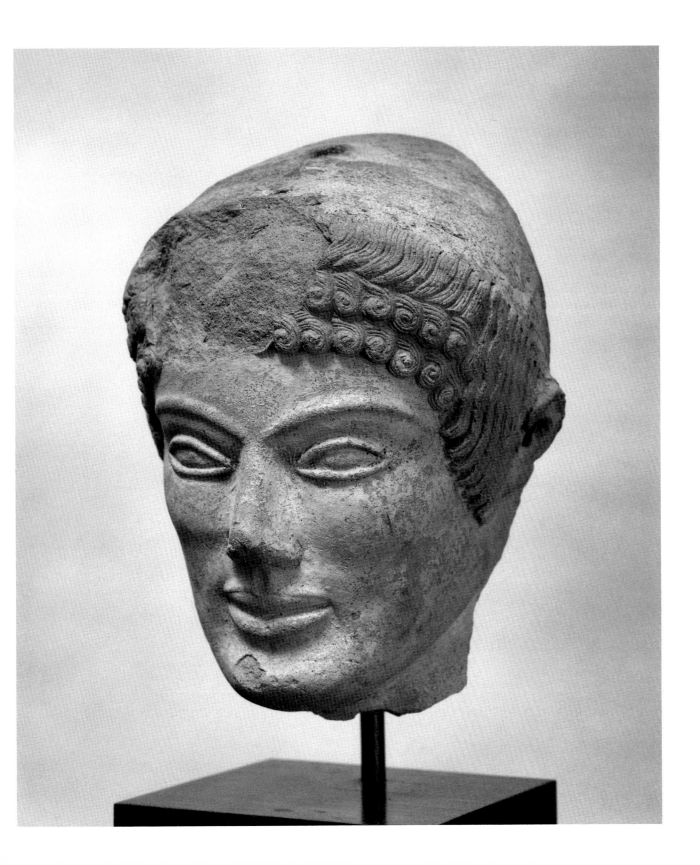

3.

Peplophoros[1]
Roman copy (1st century B.C. or 1st century A.D) of a peplophoros of the early 5th century B.C. (ca. 470–460 B.C.)
1978.4.2.
Gift of Wright S. Ludington

This three-quarter life-size standing figure of a woman wears the thick woolen Doric *peplos* (garment) with *apoptygma* (overfolds at the waist) covering the upper torso and falling in heavy folds on each side. In addition, the peplos is belted with full overfold (*kolpos*) along the waist. The lack of a tenon hole in the socket to secure and stabilize a head suggests that the head and body were carved together out of the same piece of marble; the hollowing out was thus done at some time after the head was broken off.

The Santa Barbara Peplophoros — or maiden "bearing" (wearing) a peplos — stands with her weight chiefly on the left leg; the right leg, imperceptibly bent, is slightly advanced, with the sandaled foot protruding from beneath the hem of the peplos. Attention should be called to the rather disproportionate length of the legs, particularly from the knees to the feet. The disproportion is especially noticeable when the statue is viewed from its right side, where the foot protrudes. The only acknowledgement of the body beneath the heavy drapery is to be found at the breasts, the lower thigh and knee of the right leg, and the upper buttocks.

Peplophoroi, of which the Santa Barbara Peplophoros is a good example, are a statue type that was popular during the early decades of the fifth century B.C., when the Severe Style was at its peak.[2] The ultimate prototype may well be such figures as the Stereope and Hippodamia from the east pediment of the Temple of Zeus at Olympia and the representations of the goddess Athena on several metopes

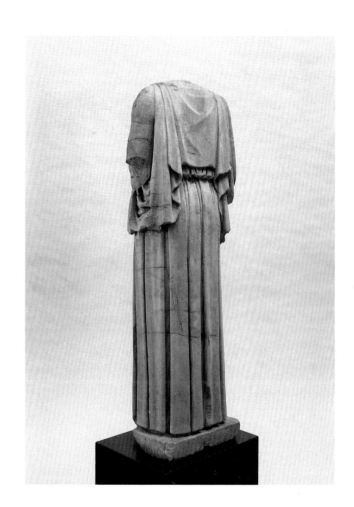

[1]C. Vermeule, *Greek and Roman Sculpture in America* (Berkeley, 1981), no. 13, p. 39.

[2]See R. Tölle-Kastenbein, *Frühklassische Peplosfiguren Originale* (Mainz, 1980); P. Sestieri, "Peplophoros," *Archeologia Classica* 5 (1953), pp. 23–33. B. S. Ridgway, "Two Peplophoroi in the United States," *Hesperia* 38 (1969), pp. 213–222; and W. Trillmich in *Jahrbuch des deutschen archäologischen Instituts* 88 (1973), pp. 277ff. and figs. 33–38.

Marble; white, coarse-grained. Height of figure, 98 cm (approx. 3 ft. 2½ in.); height with plinth, approx. 1.10 m. Plinth, 26 by 29 cm (10¼ by 11½ in.), height, 5 cm (2 in.).

The rather rough surface with its cream-toned patina originally would have been white and highly polished; traces of the original finish are evident within the deep recesses of the drapery. The head is missing, and a shallow oblong socket (8 by 12 cm long and 5 cm deep) has been hewn at the place where the head would ordinarily spring. Both arms are missing from just above the elbows. Some abrasions and minor chipping are found at scattered points along the edge of the apoptygma and the folds of the peplos. A corner on the front of the plinth is missing.

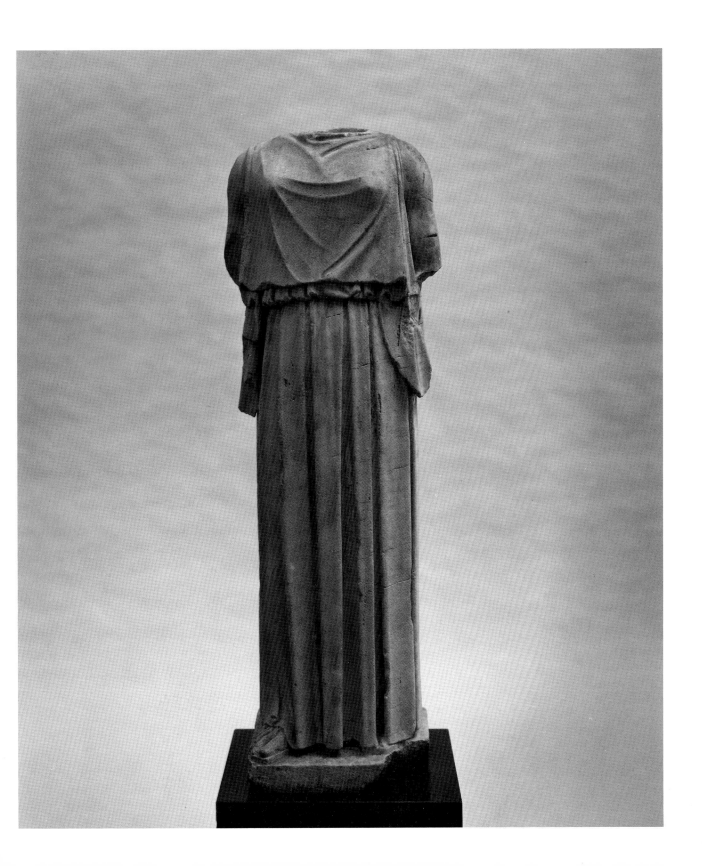

(panels between triglyphs of a Doric frieze) from the same celebrated temple.[3] Of the many peplophoroi carved in the round, and all a good deal larger in scale,[4] which reveal a close relationship to the Santa Barbara Peplophoros, the most analogous in type, style, and details is the Ludovisi Peplophoros.[5] The drapery on this statue matches that of the Santa Barbara figure almost fold for fold; the similarity is especially noticeable in the graceful sweep of the folds that run from the left shoulder to the lower edge of the apoptygma.

Many peplophoroi held their arms free above their heads, in a position of adjusting the peplos at the shoulders.[6] Though the lower arms of the Santa Barbara Peplophoros are missing, their original position can be ascertained from the character of the breakage and the fractures at the sides of the body. These show that the arms, like those of the Ludovisi Peplophoros, were held downward and slightly extended, the right arm perhaps somewhat higher and at a sharper angle than the left, as is indicated by the fully modeled folds of the peplos below the right elbow.

During the first century B.C. and the first century A.D. Roman sculptors, notably those working in the so-called Neo-Attic school,[7] were particularly fond of Greek statues of the Severe Style.[8]

[3]See G. Richter, *The Sculpture and Sculptors of the Greeks* (4th ed., rev.; New Haven, 1970), figs. 336 and 337, and figs. 336 and 444, respectively, illustrating two metopes from the Temple of Zeus at Olympia: Herakles Cleansing the Augean Stables and Herakles Bearing the Golden Apples from the Garden of Hesperides.

[4]The Hestia Giustiniani, G. Lippold, *Die griechische Plastik* (Munich, 1950), pp. 104f. and 132 and pl. 47, 1; the Copenhagen Peplophoros, Richter, figs. 337, 338; the Castel Sant'Angelo Peplophoros, E. Paribeni, *Museo Nazionale Romano, Guida* (Rome, 1953), figs. 82a and 82b; and the Peplophoros Borghese, W.-H. Schuchhardt, *Die Epochen der griechische Plastik* (Baden-Baden, 1959), p. 57, fig. 46.

[5]Paribeni, fig. 89.

[6]See note 3 above; also B. Maiuri, *Museo Nazionale, Napoli* (Novara, 1971), figs. 43 and 44.

[7]See F. Hauser, *Die neuattischen Reliefs* (Stuttgart, 1889); M. Borda, *La Scuola di Pasiteles* (Bari, 1953); G. Richter, *Ancient Italy* (Ann Arbor, 1955); and M. Bieber, *The Sculpture of the Hellenistic Age* (New York, 1961), pp. 182ff.

[8]Ridgway, *op. cit.*, p. 219, and *The Severe Style in Greek Sculpture* (Princeton, 1970), p. 73, where the Santa Barbara Peplophoros is identified as the "Candia-Kisamos-Ludovisi" type.

4.
Athena
Roman copy (Augustan?) of Athena (Ince Hall type) dating to the
late 5th century B.C.
1978.4.3.
Gift of Wright S. Ludington

FIG. 2.

Statues of Athena (and of the Doryphoros type in no. 5)
are probably among the types most familiar to museum visi-
tors with some knowledge of classical antiquity. The Santa
Barbara Athena, though many times removed from the
colossal cult statue of Athena that once stood in the Parthe-
non and was there viewed and described by Pausanias
(*Description of Greece*, 1.24.5–7) and other writers of
antiquity, nonetheless reflects the famed Pheidian original.[1]
Its immediate prototype was more likely a marble statue
modeled after the gold and ivory statue by Pheidias some-
time in the last decades of the fifth century B.C.

A number of headless Athenas stylistically parallel to
the Santa Barbara Athena have deep sockets that may
suggest that they, and others of the same sort, were designed
so that their heads were attached separately.[2] The Santa
Barbara Athena, however, clearly shows traces of hair at the
back of the neck, just left of center, as if the head were
turned slightly to the right — evidence indicating that the
statue, like the Peplophoros (no. 3), was carved all in one
piece and that the socket was carved out after the head was
broken off, to hold the repaired head or a new head. Further
support for this theory may be found in an Athena that so
resembles the Santa Barbara Athena that it may almost
be taken as a mate. This is the example known as the Ince
Hall Athena (fig. 2),[3] found in the nineteenth century at
Ostia and now in Ince Blundell Hall in England. Although
some restorations mar this fine piece, there is no doubt
that both head and body were carved from a single piece of
white marble.[4]

[1]Pheidias' statue was estimated to have stood nearly
forty feet high.

[2]C. Jacobsen, *Ny Carlsberg Glyptotek, Fortegnelse over de
Antiker Kunstvaeker* (Copenhagen, 1907), nos. 99, 100; and
*Ny Carlsberg Glyptotek 2. Tillaeg til Belledtavler af
Antike Kunstwerke* (Copenhagen, 1940), pl. VII. See also
the Ince Athena type discovered in Hadrian's Villa at
Tivoli: S. Aurigemma, "Lavori nel canopo di Villa Adriana,"
Bollettino d'Arte 39 (1954), pp. 331f.; and H. von Steuben in
W. Helbig, *Führer durch die öffentlichen Sammlungen
Klassischer Altertümer in Rom*, vol. 4 (Tübingen, 1972),
p. 165f., no. 3202.

[3]A. Michaelis, *Ancient Marbles in Great Britain* (Cambridge,
1882), p. 338f.; B. Ashmole, *A Catalogue of the Ancient
Marbles at Ince Blundell Hall* (Oxford, 1929), p. 6f., no. 8,
pls. 10 and 11; B. Ashmole, *A Short Guide to the Collections
of Ancient Marbles at Ince Blundell Hall* (Oxford, 1950).
For a list of the Ince Athena type see G. Waywell,
"Athena Mattei," *Annual of the British School at Athens
66* (1971), p. 381.

[4]The Ince Hall Athena stands 1.67 m (about 5½ ft.) in
height. Hence, considering the missing head for the Santa
Barbara Athena, the two are remarkably close in scale.
Restorations for the Ince Hall Athena are to be found at the
projecting cheek guards of the Corinthian helmet directly
above the brow, the sphinx finial, the right arm (including
hand with owl), parts of the left forearm and hand,
several toes of the left foot, and the major portion of the
vertical folds at the right leg.

Marble; white (Pentelic?). Preserved height, 1.31 m (4 ft. 3½ in.).
Surface of the white marble now bears a patina, pinkish in tone. The head is missing, but there is a deep conical cavity (15 by 18 cm, and about 14 cm deep) at the shoulders for insertion of a head. Both arms are missing. A large section of the right shoulder, including a portion of the upraised arm, drapery, and *aegis* (magical protective goatskin mantle with Medusa head and fringe of snakes), is a modern restoration in a markedly different stone that is very dense in character and gray in color. The aegis represented on the restored section has been rendered with the fringe of snakes in a "damaged" state to match those on the extant portion of the original aegis. At the left shoulder there are three square dowel holes for the attachment of the missing left arm. A single dowel hole is located at the bottom of the fractured statue in line with the right leg. From the lower part of the statue, a large section of drapery, both feet, and possibly its base or plinth are now lost.

22

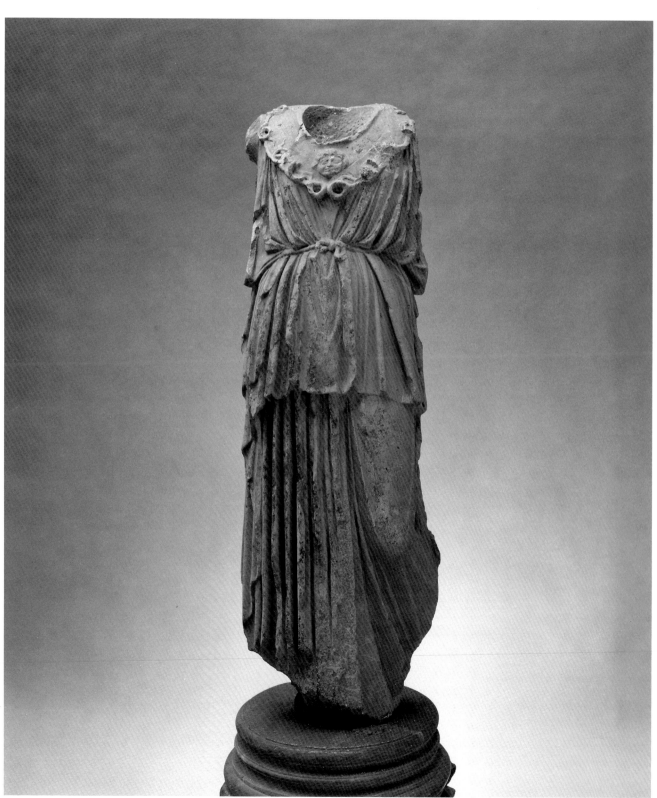

Even though large parts of the Santa Barbara Athena are missing, the pose of the goddess can be reconstructed. She stands frontally with the weight on her right leg. The left leg is noticeably bent, and the angle of the folds of the lower part of the peplos shows that the left foot, now missing, must have been poised far to the left at an outward angle from the body. One must overlook the small piece of the right arm and deltoid, part of the modern restoration in a different stone (probably done on the assumption that this was an Athena of the type in which the right arm is upraised holding a spear),[5] and look at the original modeling at the front and back areas of the restored right shoulder. This suggests that the Santa Barbara Athena held her right arm, as well as her left arm, downward in a pose similar to that of the Ince Hall Athena (though the lower half of that Athena's arm is also a restoration).

The Santa Barbara sculpture, like most Athenas of the Ince Hall type, wears the peplos. The overfold (apoptygma) reaches to about mid-thigh, and a pouchlike kolpos is formed at each hip by the tight belting. The aegis with its gorgoneion (Medusa head) is also a traditional ornament in Athenas of this type, although it appears in many variations. Here it is rather narrow.[6] This, too, is strikingly similar to the Ince Hall Athena. The differences in the patterns of folds in the drapery of the two Athenas are decidedly minor and in no way diminish the possibility that the two statues may have come from the same workshop.

It is tempting to see in the Santa Barbara Athena something of Myron's portrayal of the goddess in his Athena-Marsyas group, which stood on the Akropolis.[7] In that case the prototype could be not the Athena Parthenos but an earlier one of the fifth century attributed to Alkamenes, a contemporary of Pheidias.[8] The weight of the evidence, however, remains with Ashmole's proposal that the Ince Hall Athena — and therefore the Santa Barbara Athena — is a Roman copy based on a late-fifth-century original inspired by the earlier Athena Parthenos by Pheidias.

[5] Although not conforming strictly to the Ince Hall Athena type, see the Louvre Athena Velletri: A. Furtwängler, "Über Statuenkopien im Altertum," *Abhandlungen Bayer* 20 (1896), pp. 32f. See *American Journal of Archaeology* 81 (1977), p. 151, fig. 8.

[6] Others of a similar narrowness appear on a headless torso in Rome, M. Mustilli, *Il Museo Mussolini* (Rome, 1939), pp. 129–130, no. 18, pl. LXXX; on a torso with head in New York, G. Richter, *Catalogue of Greek Sculptures in the Metropolitan Museum of Art* (New York, 1954), no. 65, pl. LIX; on a headless figure in Venice, G. Traversari, *Sculture del V–IV secolo a.c. del Museo Archeologico di Venezia* (Venice, 1973), p. 66f., no. 25; and on the two in the Ny Carlsberg Glyptotek cited in note 2 above.

[7] See G. Richter, *The Sculpture and Sculptors of the Greeks* (4th ed.; New Haven, 1970), figs. 629 and 631. G. Daltrop, *Gruppo Mironiano di Atena e Marsia nei Musei Vaticani* (Rome, 1980).

[8] Attention is here called to the Alkamenes and the Velletri Athena type not on the basis of the drapery but because the head and the Corinthian helmet are analogous to those of the Ince Hall Athena. See E. Harrison, "Alkamenes' Sculptures for the Hephaisteion," *American Journal of Archaeology* 81 (1977), pp. 137–178, with list of the Velletri Athena type, pp. 175ff.

5.
Torso of the Doryphoros
Roman copy (Hadrianic) of the Doryphoros by Polykleitos of
ca. 440 B.C.
1955.3.1
Gift of Wright S. Ludington

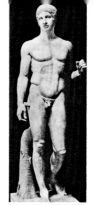

FIG. 3.

24

This exceptionally fine, more than life-size torso of an
athlete brings directly to mind one of the best preserved of
the numerous Roman copies of the much-admired Dory-
phoros (Spear-bearer) by Polykleitos, that is, the specimen
from Pompeii now in the Museo Nazionale at Naples (fig. 3).
Though fragmentary, the Santa Barbara Doryphoros shows
not only that quality of solidarity or "squareness" so
often equated with Polykleitos' Argive origin and character-
istic of the so-called Peloponnesian school, but also the
harmonious symmetry of design that Polykleitos perfected
in his sculpture according to his canon on the proportions of
the male form.[1] All the marble copies of Polykleitos'
original bronze Doryphoros show something of the "hard-
ness" and surface character of the muscles.

The Doryphoros was evidently a particular favorite
among the Romans, for there is a remarkably large number
of copies, in varying states of preservation.[2] A good deal
of study has gone into the problem of dating these copies.[3]
The Santa Barbara Doryphoros, though easily enough
identified, is not easily dated. On the evidence of the apparent
faithfulness to the fifth-century Classical style and the
highly polished surface of the marble, the torso may be
appropriately attributed to the Hadrianic period
(A.D. 117–138).[4]

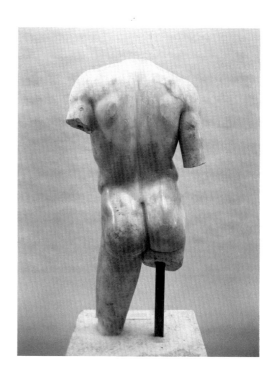

[1]See R. Carpenter, *The Esthetic Basis of Greek Art of the
Fifth and Fourth Centuries B.C.* (Bloomington, 1959),
pp. 89–96; H. von Steuben, *Der Kanon des Polyclet*
(Tübingen, 1973); and R. Tobin, "The Canon of Polykleitos,"
American Journal of Archaeology 79 (1975), pp. 307–321.

[2]P. Arias, *Policleto* (Rome, 1964), pp. 41–48; see also
C. Vermeule, *Polykleitos* (Boston, 1969), and T. Lorenz,
Polyclet (Wiesbaden, 1972). Quintilian (*Inst. Ot.* 5.12.21)
in the first century A.D. advised Roman sculptors to use
Polykleitos' Doryphoros as a model for their military
and athletic statues.

[3]See H. Lauter, *Zur Chronologie römischer Kopien nach
Originalen des V. Jahr.* (Berlin, 1970), pp. 45–108.

[4]One of the closest stylistic parallels to the Santa Barbara
Doryphoros is offered by the Doryphoros torso from Tunis
presently in the Bardo Museum (Lorenz, pl. XXVII, fig. 1),
which Lorenz assigns to his third phase or "optisch" style
of copies produced during the Hadrianic era. See also the
Torso in Berlin, SK 1789 (598): E. Rohde, *Griechische und
römische Kunst in den Staatlichen Museen zu Berlin*
(Berlin, 1968), fig. 75.

Marble; white, fine-grained. Preserved height, 1.25 m (4 ft. 1¼ in.).
The fine-grained marble is highly polished and shows some scattered abraded areas. The head is missing, and there is a large squarish dowel hole with traces of wood (peg?) at the neck. Both arms are missing: from the elbow down for the right arm, from mid-biceps for the left. On the lower extant portions of both arms there are rectangular dowel holes with trench or groove for attaching the missing lower arms. A hole at the lower right hip must have served to anchor a "strut" to strengthen the right forearm. The lower portions of the legs are also missing: from the mid-thigh for the right leg, from just above the knee for the left. There is some marble "patching" of which the most conspicuous is the large segment at the upper front thigh. All traces of repair are modern, possibly seventeenth or eighteenth century.

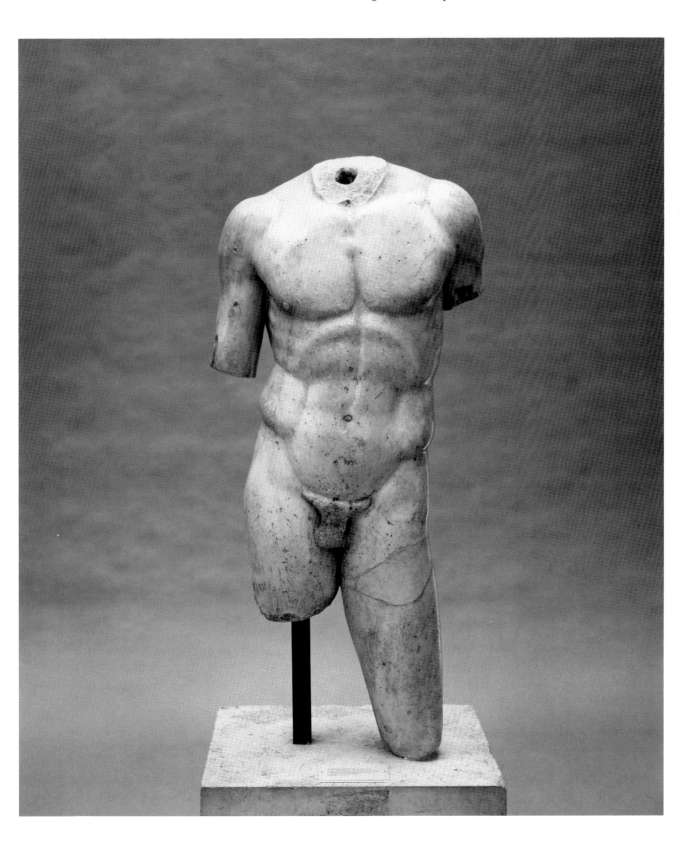

6.
Head of a Youth (Ares Ludovisi Type)
Roman copy (1st century A.D.; Flavian?) of a Greek original of the
mid-4th century B.C.
1978.4.6
Gift of Wright S. Ludington

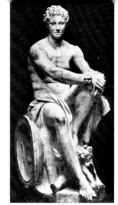

FIG. 4.

26

This life-size head, marred but still handsome, is a copy of a
head customarily associated with one of the best-known
Greek statues, the Ares Ludovisi (fig. 4).[1] Of the various
sculptors to whom the original Ares (Latin Mars) has been
attributed, Skopas of Paros (fourth century) seems the
most likely choice. The Santa Barbara head represents a type
known from at least eight close copies and an additional
number of so-called "free" copies — that is, versions of the
original that reflect the basic character of the prototype
but differ markedly in details.[2] The popularity of this head
type among Roman copyists is documented by the frequent
appearance of closely related replicas on standing or seated
statues, and also on herms (pillars surmounted by heads).[3]

The Santa Barbara head is a particularly fine close
copy of the Ares Ludovisi type in that its surface, though
damaged, shows no sign of the reworking that was often
done to antique statues during the Renaissance and later.[4]
The modeling is extremely sensitive, especially on the nose
and forehead with its pronounced swell of the brow (best
seen in profile). It is in the best fourth-century tradition
of Skopas, Praxiteles (for example, Hermes and the Infant
Dionysos), and Lysippos (especially the Apoxyomenos
and portrait heads of Alexander the Great). The deep-set
eyes, slightly parted mouth, and swell of the brow on the
Santa Barbara head are more characteristic of Skopaic than
of Praxitelean or Lysippic workmanship.

[1]W. Helbig, *Führer durch die öffentlichen Sammlungen
klassicher Altertümer in Rom*, vol. 3 (Tübingen, 1969), pp.
268 ff. See also *Mitteilungen des deutschen archäologischen
Instituts, Rom* (hereafter *RM*) 71 (1964), pl. 36, figs. 1–3.

[2]See G. Lippold, *Die griechische Plastik* (Munich, 1950),
p. 289; *RM* 73–74 (1966–1967), pl. 92, figs. 2–3; J. Paul
Getty Museum, inv. no. I.59, M. Del Chiaro, *Greek Art in
Private Collections of Southern California* (Santa Barbara,
1963, 1966), no. 22 and inv. no. 71.AA.119, C. Vermeule
and N. Neuerburg, *Catalogue of the Ancient Art in the
J. Paul Getty Museum* (1973), no. 53.

[3]See J. Fink, "Ein Kopf für viele," *RM* 71 (1969), pp. 152–
157 and pls. 34–38; D. Rinne and J. Frel, *The Bronze Statue*

of a Youth (J. Paul Getty Museum, 1975); H. von Heintze,
"Doppelherme mit Hermes und Herakles," *RM* 73–74
(1966–1967), pp. 251–255 and pls. 90–92; F. Causey, "Six
Additional Heads of the Ares Ludovisi Type, *The J. Paul
Getty Museum Journal* 4 (1977), pp. 77–87, in particular,
no. 5 and p. 85, fig. 7; S. Lattimore, "Ares and the Heads of
Heroes," *American Journal of Archaeology* 83 (1979),
pp. 71–78, pls. 2–10.

[4]The reworking was often done by reputable sculptors who
were commissioned to do the restoration on recently
discovered pieces — such as Michelangelo for the celebrated
Laocoön in 1506 and Bernini for the Barberini Faun during
the second quarter of the seventeenth century.

Marble; white, fine-grained (Pentelic?). Height, 35.5 cm (approx. 14 in.).
The surface of the marble is worn, particularly at the crown and on the right side
of the hair. Pitting and abrasions occur throughout. A deep fissure runs down
the left side of the head, across the crown, through the eye, and down to the jaw
line. A slice of hair on the left side of the head is altogether missing. A good
portion of the nose and parts of the lower lip are broken or chipped away.

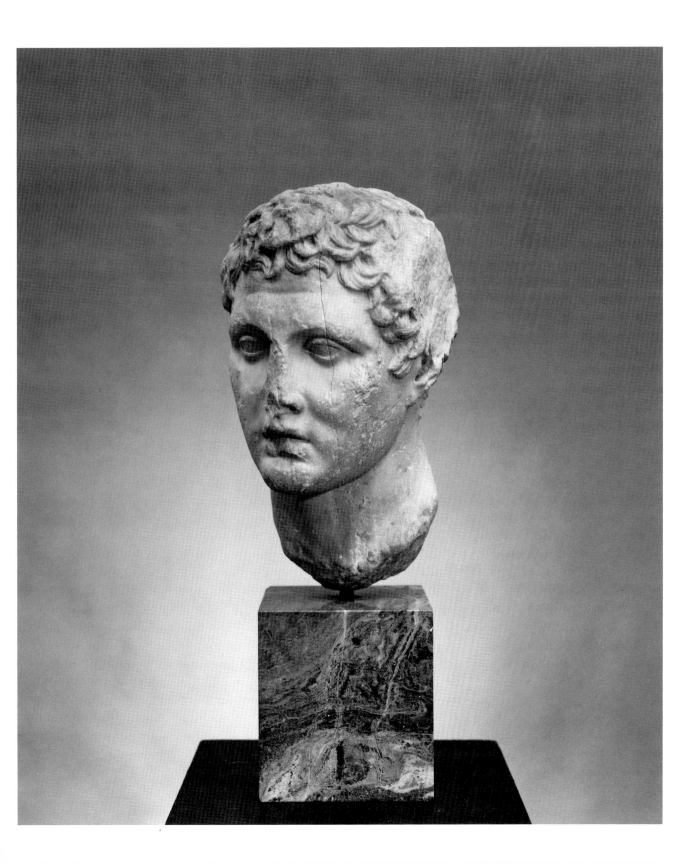

7.

Headless Torso of a Youth (Apollo?)
Roman copy (Augustan?) of a Greek original (Apollo Kitharista?) in
the Praxitelean tradition of the 4th century B.C.
1971.69
Purchased with funds provided by the Dan Murphy Foundation
(Formerly Russell McKinnon Collection)

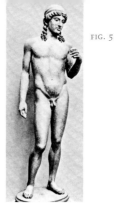
FIG. 5.

FIG. 6.

This statue, almost three-quarters life-size, is a youthful, somewhat effeminate figure in a standing position with the weight supported on the right leg. The position of the arms is significant. Both arms were evidently held downward, the right one rather close to the body. The chipping on the upper right thigh may indicate that there was originally a marble strut connecting the leg to the wrist at this point. The angle of the fragmentary left arm appears to indicate that this arm was held out from the body, somewhat trailing. This position of the arms could certainly suggest that the Santa Barbara Torso of a Youth depicted an Apollo Kitharista — that is, the god Apollo holding in his left arm a *kithara* (a heavy lyre-like instrument), indicative of his association with the Muses, and a plectrum or pick in his right hand.[1] The character of the body, the pose, and the modeling recall a mid-fifth-century bronze Apollo Kitharista from Pompeii now in Naples (fig. 5).[2] But there are other possible interpretations of the downward arm position. The Santa Barbara youth may have been carrying drapery of some sort on his left forearm, as do several statues of a similar type.[3] Or he may simply have been standing in a graceful but not especially significant pose; for this type, too, there are parallels.[4] It may even be possible that this figure with his tendrils of hair was a Dionysos or Bacchus. As pointed out in the introduction, some gods that were at first depicted as virile gradually took on an increasingly effeminate character in the Hellenistic period — Dionysos in particular.[5]

The elegant body with graceful S-curve and sensitive treatment of the anatomy has an undeniably Praxitelean flavor, strongly reminiscent of the Apollo Sauroktonos (fig. 6), a statue that shows superbly the fourth-century mastery of the integration of muscle and flesh. With these features in mind, we find a close relationship between the Santa Barbara Torso of a Youth and the torso of a youth in Providence, Rhode Island (though the latter had its right arm upraised).[6] Whatever the exact pose of the Santa Barbara youth may have been, the figure certainly seems to represent the strong tradition of Praxiteles responsible for so many statues produced throughout Roman times.[7]

[1] An Apollo Kitharista carrying a heavy kithara with the aid of a strap across his shoulder and chest was discovered at Leptis Magna: *Bollettino d'Arte* 38 (1953), p. 4, fig. 8.

[2] B. Maiuri, *La Musée Nationale: The National Musem, Naples* (Novara, 1959), p. 55, and *Museo Nazionale, Napoli* (Novara, 1971), fig. 42. An Apollo Kitharista or Apollo Musegetes (Leader of the Muses) often served appropriately as a niche or pedestal figure in theaters and libraries.

[3] B. Maiuri, *Museo Nazionale, Napoli*, fig. 52 and *Bollettino d'Arte* 36 (1951), p. 195, fig. 4.

[4] See T. Kraus, *Das Römische Weltreich, Propyläen Kunstgeschichte*, vol. 2 (Berlin, 1967), pls. 272 and 273.

[5] See, e.g., A. Blanco, *Museo del Prado, Catalogo de la Esculture* (Madrid, 1957), pl. XL, 44-E.

[6] B. S. Ridgway, *Catalogue of Classical Sculpture in the Rhode Island School of Design* (Providence, 1972), no. 26. The right arm of this figure, as Ridgway rightly observes, was upraised and probably rested on top of his head: see G. Rizzo, *Prassitele* (Milan, 1932), pl. 120. See also M. Bieber, *The Sculpture of the Hellenistic Age* (New York, 1961), fig. 17. Another close stylistic example, although not as slim as the Santa Barbara youth, is presently in Rome; see A. Giuliano, ed., *Museo Nazionale Romano, Le sculture*, I.2 (Rome, 1981), pp. 331f., Ala IV, no. 36 (no inv. number).

[7] The popularity of such graceful Praxitelean types can be appreciated by studying the numerous examples given in S. Reinach, *Répertoire de la statuaire grecque et romaine*, 6 vols. (Paris, 1897–1930, with Rome reprints, 1965–1969); see especially vol. 1, pp. 238, 250; vol. 4, p. 66 (cf. *Notizie degli Scavi*, 1909, p. 87, fig. 2); and vol. 5, pp. 39 and 48.

Marble; white, fine-grained. Preserved height 83 cm (approx. 2 ft. 9 in.).
The head and most of the neck are missing. A long, wavy tress of hair falls on each side and over the front shoulder. Both arms are missing from the biceps, somewhat more of the bicep remaining on the left arm than on the right. The right leg is preserved from the groin to just above the knee; the left is missing from the upper thigh down. The penis is also missing. There is a squarish dowel hole on the underside of the extant portion of the left leg. A hole, apparently modern, has been drilled at the back between the shoulder blades, presumably to secure the statue to a wall. There is considerable abrading and pitting. Hard encrustation appears along the right side of the torso at the ribs and hip and across to the right side of the abdomen; also on the left side of the torso and what remains of the left leg; it is especially heavy on the left shoulder and preserved upper left arm. The entire back of the body was also thickly encrusted at one time but has been partly cleaned.

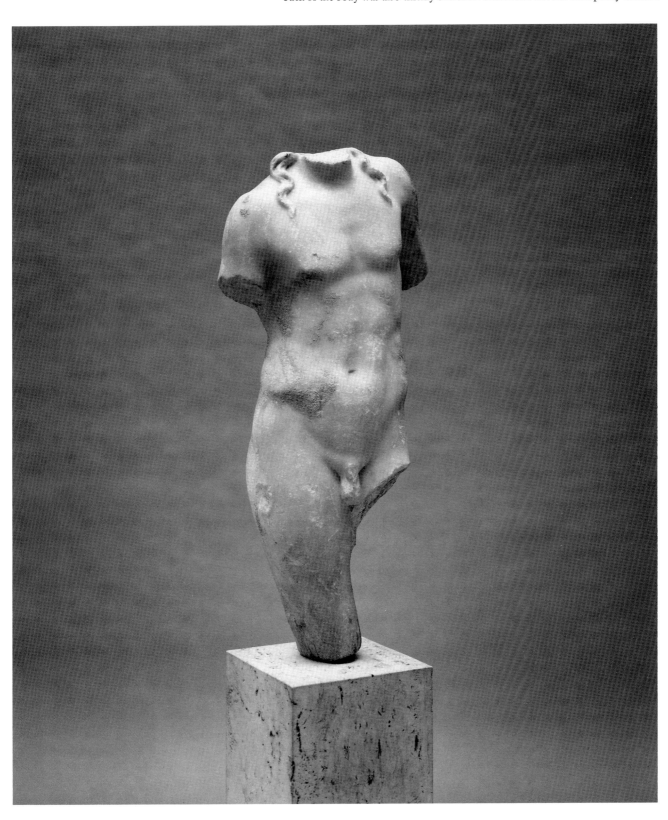

8.
Relief of Three Dancing Nymphs
Roman copy (1st century A.D.) of a Greek original of the
4th century B.C.
1952.27
Gift of Frank Perls

Against a plain background, three maidens dance in a row
toward the left. Over their chitons they are wrapped in
voluminous, delicately fluttering himatia or mantles. The
leader, head in profile, has her hair bound up. The second
dancer tilts her face slightly toward the beholder, in
three-quarter view. Her hair, partly confined by a scarf,
surrounds her forehead in soft waves and flows in a mass of
curls down her back. The third girl looks directly outward.
Her face is framed by the himation, which is pulled up to
cover her hair. Each girl holds on to the one in front of her
by an end of the himation, just as dancers hold on to each
other by handkerchiefs, shawls, or belts in more recent
forms of chain dance.

 The relief belongs to a series of replicas showing the
same three dancers and agreeing closely in their details.
In his study of the neo-Attic reliefs, W. Fuchs discusses ten
surviving examples.[1] The list might be still longer if
fragments, variants, and new finds were included. All must
reproduce a famous lost original, datable on stylistic
grounds to the third quarter of the fourth century B.C.[2]

 In some versions the girls are identifiable from their
context as nymphs.[3] New research by Charles Edwards
attributes the prototypes of these, along with some other
figures surviving in Roman copies, to a relief scene
decorating the base of a statue of Dionysos, probably
by Praxiteles, in the god's sanctuary at Athens.[4] In the
reconstructed scene the messenger-god Hermes was
shown carrying the infant Dionysos, newborn from the thigh
of Zeus, to the nymphs who would rear him secretly in the
mountain wilderness of Nyssa. Ino, also called Leucothea,
served as foster mother to the divine child. The three
attendant nymphs dance in celebration of the glad event, or
simply as an expression of their harmonious and beneficent
nature.

 Because of its exceptional preservation and rather
academic-looking style, the authenticity of the seemingly

[1]W. Fuchs, *Die Vorbilder der neuattischen Reliefs* (Berlin,
1959), p. 21 for a list, pp. 20–27 on the type.

[2]Fuchs, pp. 22–23; he suggests a date in the decade 340–330.

[3]Fuchs, p. 21, nos. A1–A3 are votive reliefs where the
dancers are characterized as nymphs.

[4]A preliminary report of these studies was delivered by
Mr. Edwards at the 84th General Meeting of the Archaeolog-
ical Institute of America in Philadelphia, Dec. 27th–30th,
1982. Cf. the summary in the *Abstracts* of that meeting.

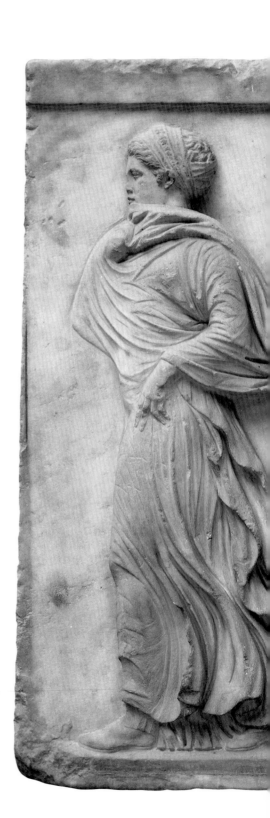

Marble; white, medium-fine grained (Pentelic). Height, approx. 72.9 cm (2 ft.
4¾ in.); length, approx. 86.3 cm (2 ft. 10 in.) top; approx. 90.2 cm (2 ft. 11½ in.)
bottom; depth, approx. 7.7 cm (3 in.).
This relief is almost intact except for damage to noses of second and third figures,
minor chips and abrasions elsewhere. The surface has been whitened by a
too-drastic cleaning.

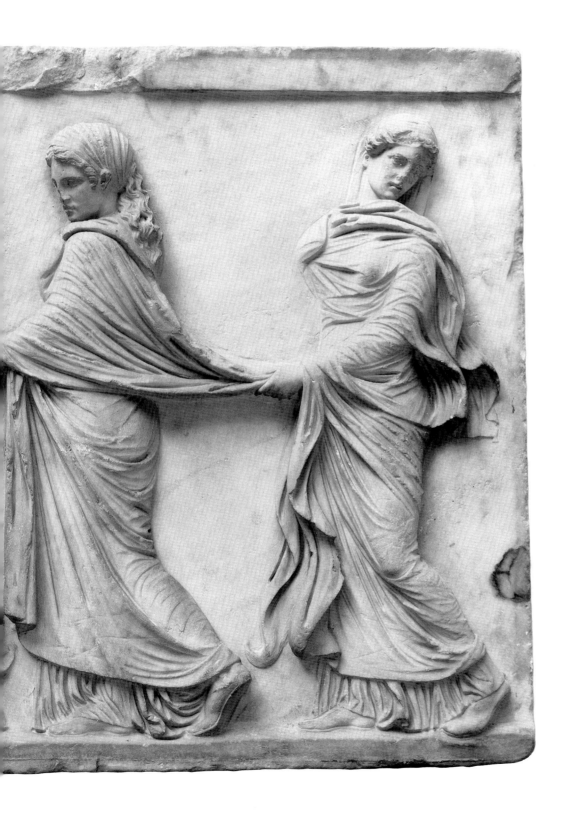

unprovenanced Santa Barbara relief has been questioned. Now, however, it can be identified as one found between Tripoli and Leptis Magna in modern Libya, apparently soon before its first publication in 1896/7.[5] The sculpture was acquired in North Africa by an Englishman, H. Swainson Cowper, who kept it in his home, Yew Field Castle, Outgate, Ambleside, and exhibited it at Cambridge in 1911. A 1933 photograph of the Swainson Cowper relief in the German Archaeological Institute at Rome[6] is clearer than the illustrations published earlier and shows the same veinings, the same slight flaws and discolorations still visible in the Santa Barbara piece despite an evident vigorous cleaning since the picture was taken. The German Institute photograph was reproduced by Fuchs in 1959, but when the actual piece came to the Santa Barbara Museum from the Perls collection in 1952, information about its past had been lost.

The relief's history leaves little doubt as to its authenticity. At the time of its discovery, the examples best known today, found at Piraeus in 1931,[7] had not yet appeared. Others, fragmentary or in obscure museums, were not widely studied and illustrated as they have been since. There were no versions of similar quality and completeness accessible to nineteenth-century forgers of marble sculpture, usually active in Rome or Naples and dependent on models in the museums there.

The material of the Santa Barbara relief is Pentelic marble, quarried near Athens and recognizable by its rather opaque appearance, medium-fine grain, streaky grayish discolorations, and micaceous inclusions. The piece, like many of the finest sculptures of Roman date found in the same region, must have been an ancient import from Athens.[8] The slightly inward-sloping sides show that the plaque was not part of a continuous frieze, but an independent decorative panel to be set in a wall or even displayed atop a freestanding pedestal.[9] Such pieces adorned the gardens of elegant villas throughout the Roman world.

Replicas of this type correspond so closely in all their main features that a precise dating of this version is difficult. However, the lush but subtle carving of the drapery, the soft, small-boned faces, and the rather de-emphasized movement suggest artistic trends of Claudian times, in the second quarter of the first century A.D. The colder late-Hadrianic examples from Piraeus show that the type was still in production at Athens, presumably for export, a century later.

Ariel Herrmann

[5]J. L. Myres, "A Marble Relief from the African Tripolis," in *Annual of the British School at Athens*, 3 (1896/7), pp. 170–174, pl. 14. Later publications of the Swainson Cowper relief are S. Reinach, *Monuments nouveaux de l'art antique*, II (Paris, 1925), p. 89, fig. 301; R. Feubel, *Die attischen Nymphenreliefs und ihre Vorbilder* (Heidelberg, 1935); Fuchs, p. 21, no. A4, c, with commentary pp. 25–27, pl. 3a.

[6]Institute Negative 33.1756; the first two digits indicate the year the photo was made .

[7]Fuchs, p. 21, A4, d (two replicas from the same find).

[8]See, for example, E. Paribeni, *Catalogo delle sculture di Cirene* (Rome, 1959), passim. Most of the ambitious sculptures dating from early and high Imperial times are said to be of Pentelic marble.

[9]E. Dwyer, in *Römische Mitteilungen*, 88 (1981), pp. 247ff., p. 285 for *pinakes* or decorative relief panels and the practice of displaying them on freestanding supports. See also the relief-within-a-relief, the votive *pinax* with three dancing nymphs represented on the neo-Attic krater in the Metropolitan Museum, G. M. A. Richter, *Catalogue of Greek Sculptures* (Oxford, 1954), no. 60, pl. LII. The size and thinness of the Santa Barbara plaque, however, admittedly make it more likely that the piece was attached to a wall.

9.
Torso of Herakles
Roman copy (Hadrianic?) ultimately derived from an original of the
last quarter of the 4th century B.C. by Lysippos
1978.4.5
Gift of Wright S. Ludington

Marble; white, fine-grained. Preserved height, 82 cm (approx. 2 ft. 8 in.).
The head, both arms and legs, and genitalia are missing. A stone matrix remains
along the left side of the body below the left armpit and at the side of the
left thigh. An additional matrix adheres to the upper right buttock. The extensive
pitting and abrasions have been glossed over by a waxlike substance. Patching
occurs at the right pectoral and there are plugs for the nipples of the chest.

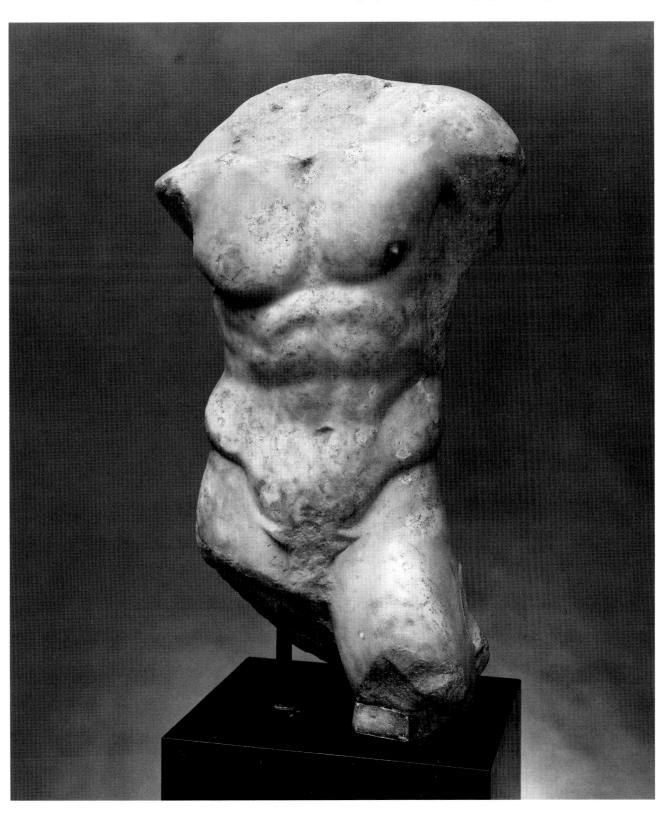

The presence of a stone matrix below the left armpit and another on the upper right buttock are significant to the identification of the well-muscled, almost life-size Santa Barbara torso. This figure (once in the Tissot collection and later in the Hearst collection) is unmistakably a Herakles type generally known as the "Weary Herakles."[1] The Greek hero is at rest, in a posture best known from the large-scale Farnese Herakles in Naples (fig. 7), often seen in Hellenistic and Roman statuary ranging in scale from statuettes to colossi.[2]

The Farnese Herakles leans heavily on his massive club, its roughness cushioned by the familiar Heraklean lion skin. He holds his right arm behind him, the back of the hand against his right buttock, three apples within its grasp. He is resting after the successful completion of one of the last of his mighty labors, the acquisition of the Golden Apples from the Garden of the Hesperides. The matrices located on the right buttock, below the left arm, and at a point on the left thigh of the Santa Barbara statue clearly show that the pose and type of the Santa Barbara Herakles is similar to the Farnese Herakles. A further detail, the fracture at the neck, would seem to bear out the supposition that this Santa Barbara torso is a Herakles of the Farnese type. The diameter of this fracture is too large for an ordinary neck and indicates at least a full beard, and very likely also a head bent down as on the Farnese Herakles.

Cornelius Vermeule has classified examples of the "Weary Herakles" into four groups, the first group being those he considers closest to the original; he puts the Farnese Herakles in the third group.[3] The Santa Barbara Herakles probably belongs in group two. The modeling of the muscles on the torso is far less exaggerated on the Santa Barbara Herakles than it is on the Farnese Herakles, and this more natural rendering of the anatomy helps to place the Santa Barbara Herakles closer to the style current in the second half of the fourth century B.C., specifically to the work of Lysippos, the sculptor to whom the prototype is attributed.[4] The closest known parallel to the Santa Barbara Herakles is the marble statue in the Galleria degli Uffizi in Florence, which Vermeule lists in his second group ("Hellenistic Modifications").[5] One can conclude that the Santa Barbara Herakles — one of the most significant pieces in the collection — is probably a Roman copy based on a Hellenistic version of the original by Lysippos.

[1]See S. Reinach, *Répertoire de la statuaire grecque et romaine*, vol. 5 (Paris, 1913), p. 99, no. 2. C. Vermeule, "The Weary Herakles of Lysippos," *American Journal of Archaeology* 79 (1975), pp. 323–332.

[2]See Vermeule; also C. Havelock, *Hellenistic Art* (Greenwich, Conn., 1969), fig. 81, and G. Richter, *The Sculpture and Sculptors of the Greeks* (4th ed., New Haven, 1970), figs. 802–804, for a bronze statuette, and M. Bieber, *The Sculpture of the Hellenistic Age* (New York, 1961), fig. 84, for a marble colossos.

[3]Vermeule, pp. 324–326.

[4]See F. Johnson, *Lysippos* (Durham, N.C., 1927), and E. Sjöqvist, *Lysippus* (Lectures in Memory of Louise Taft Semple, Series 2, 1966–1970). It should be pointed out that

the plugs for the nipples of the Santa Barbara Herakles are additions, probably from the Renaissance or later (seventeenth or eighteenth century).

[5]G. Mansuelli, *Galleria degli Uffizi, le sculture*, vol. 1 (Rome, 1958), fig. 98; Vermeule, p. 325, no. 3.

10.

Draped Apollo Kitharista[1]
Roman copy (Julio-Claudian?) of an original of the 4th century B.C.
1971.51.1
Gift of Wright S. Ludington

This handsome life-size statue unquestionably represents an Apollo Kitharista in mid-stride. The left or free leg is noticeably bent, with the hips thrust forward, creating in profile a graceful, crescentlike contour.[2] The god wears a sleeveless chiton (linen tunic), which is belted to form full kolpoi (overfolds) on each side of the front just below the waist. The kolpoi, the sweeping drapery of the himation (wool mantle), and the folds of the chiton between the legs are accentuated by deep undercutting in the marble. The drapery is only cursorily treated on the back, however, in a series of U-shaped folds that sketch in the mantle falling from the neck to the ankles. One end of the mantle hangs loose near the left hip.

The preserved portion of the right arm clearly indicates that this arm was held down at the side, with the forearm projecting slightly out from the body. Though less remains of the left arm, it clearly was drawn slightly back. The position could have been similar to that in the Apollo Kitharista in Naples (fig. 5), thus giving Santa Barbara two Apollos of this type. The square dowel holes at the left deltoid and near the left hip are important evidence for such a conjecture, for they are in the right position to secure the kithara. The patina inside the upper dowel hole would indicate that the kithara, if there was one, was removed very early in the life of the statue.

A remarkably close parallel to the Santa Barbara Draped Apollo Kitharista is offered by a statue in Berlin (fig. 8). The Berlin statue is much restored, but nonetheless its pose, gesture, and style of drapery are so similar to those of the Santa Barbara statue as to suggest that both were produced by the same workshop.[3] The transparent quality of the drapery — best noted on the chest, left leg, and lower portion of the right leg — bears a resemblance to Greek sculpture of the late fifth century B.C., as on the pedimental sculpture of the Parthenon and on the reliefs of the balustrade of the Temple of Athena Nike on the Akropolis. But the quality of the transparency along with the heavy folds of rather loose, billowing drapery is more characteristic of the fourth century and therefore suggests that a statue of the later period was the prototype for the Santa Barbara Apollo.[4]

The very flat, unfinished character of the back of the Santa Barbara Draped Apollo Kitharista is a good indication that the figure was designed for a niche, probably in a theater or library, and probably just above eye level, judging from the general sweep, the deep undercutting of the kolpoi, and other details of the drapery.[5]

35

[1]C. Vermeule, *Greek and Roman Sculpture in America* (Berkeley, 1981), no. 55, p. 85.

[2]M. Del Chiaro, "New Acquisitions of Roman Sculpture at the Santa Barbara Museum of Art," *American Journal of Archaeology* 78 (1974), p. 68f.

[3]C. Blümel, *Staatliche Museen zu Berlin, Katalog der Sammlung Antiker Skulptur*, vol. 4 (Berlin, 1931), p. 25, no. K 163 and pl. 49; C. Blümel, *Die Archäische Griech-ischen Skulpturen der Staatlichen Museen zu Berlin* (Berlin, 1964), pl. 49; and S. Reinach, *Répertoire de la statuaire grecque et romaine*, vol. 2 (Paris, 1904), p. 105, no. 7. The modern restorations for the Berlin Apollo Kitharista are the following; head, neck, arms (and kithara), major portions of the billowing drapery, the diagonal fold across the chest, the front half of the right foot, and the entire left foot to the ankle. For a few other examples of draped Apollo Kitharista see G. Lippold, *Die Skulpturen Vaticanischer Museums*, III, 1 (Berlin, 1936), pl. 3, no. 495: pl. 7, no. 516; and pl. 51, no. 582.

[4]Examples of this combination of drapery may be found on statues of Roman vintage in Boston and elsewhere. See C. Vermeule, *Greek, Etruscan, and Roman Art in the Boston Museum of Art* (Meriden, Conn., 1963), figs. 219, 220; C. Havelock, *Hellenistic Art* (Greenwich, Conn., 1971), pls. 128, 129; M. Bieber, *The Sculpture of the Hellenistic Age* (New York, 1961), figs. 678–681.

[5]See M. Bieber, *Ancient Copies* (New York, 1977), pl. 80.

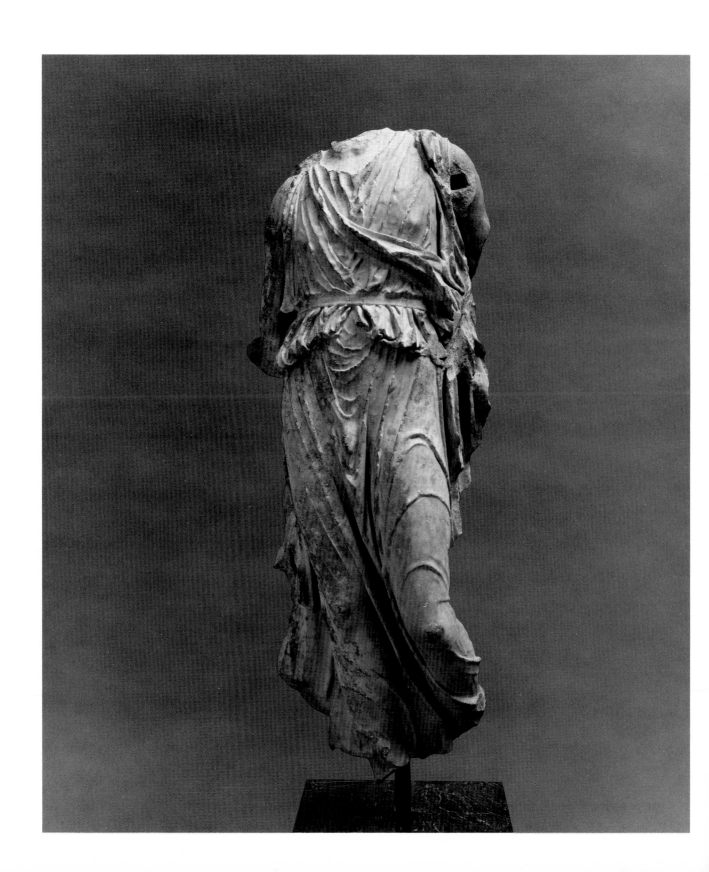

Marble; white, fine-grained. Preserved height, 1.50 m (4 ft. 11 in.).
The fine marble carries a warm, light brown patina. The head has been broken off, but some of the neck remains. Both arms are missing, the left from mid-biceps, the right from just below the elbow. The right ankle remains, but the feet and lower ends of the drapery are lost. The statue is supported by a dowel set into the back folds of the drapery at the base. Large sections of the drapery are missing, and there is some chipping in the folds of the drapery at the front, especially near the lower edges of the massive trailing drapery on either side. A round dowel hole at the neck has been made for reattaching the now missing head. There are two squarish dowel holes on the left arm. The conspicuous upper hole (approx. 4 cm in depth) in the forward part of the deltoid shows traces of rust, although the hole itself has the same surface patina as on the rest of the statue. Only the bottom part of the lower hole is barely discernible, below the upper dowel hole in line and about even with the elbow.

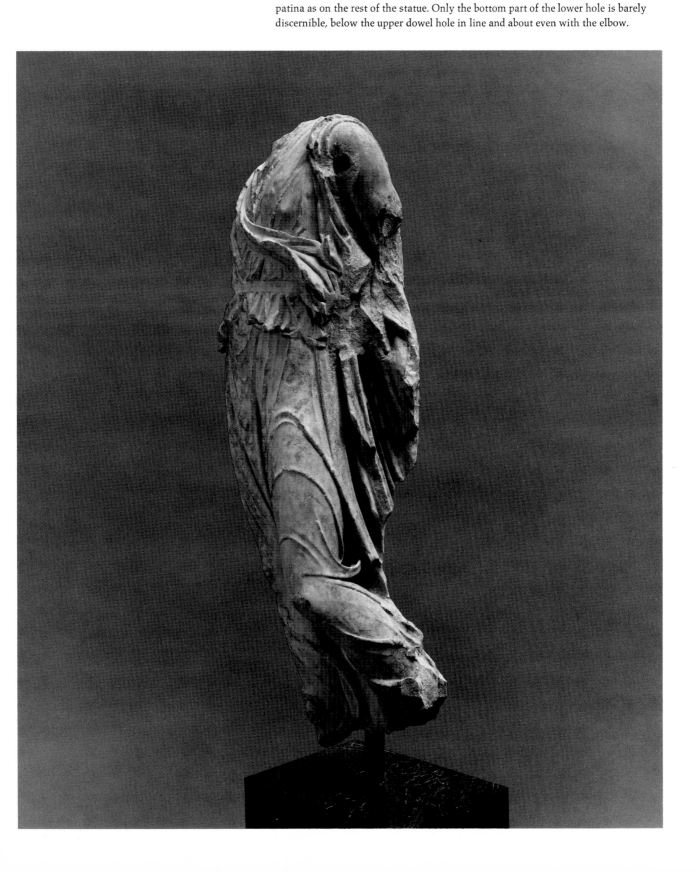

11.

Draped Female Torso
Roman copy (1st century A.D.?) of a Greek original of the
3rd century B.C.
1978.4.7
Gift of Wright S. Ludington

FIG. 9.

FIG. 11.

38

Of acknowledged superior workmanship,[1] this fragment
offers an interesting challenge to the scholar who wishes to
determine its ultimate prototype and trace the original
theme through the numerous versions and adaptations made
by Roman copyists. The figure stands frontally, but with
the torso twisted noticeably to the left; the weight was
borne on the right leg, and the left leg was raised, with the
foot probably resting on some sort of support. The drapery
shows a fine contrast in texture between the light, clinging
chiton that covers the upper body and the heavy himation
that wraps the body in a loose, sweeping fold, dropping
down at the right and angling up to the left in front (cf.
no. 10). The girdle or cord is worn unusually low but
tightly enough to create a kolpos on the right hip.

Since the preserved portion of the left leg makes it
possible to determine, in general, the actual pose of the Santa
Barbara Draped Torso, we can begin by looking at statues
of similar pose. Three relatively well-known statues suggest
a possibility: the Venus of Capua (fig. 9), the Venus of
Melos, and the large bronze Victory of Brescia (fig. 10). To
these may be added the Roman Venus with Mars (fig. 11).
Together these statues illustrate the gradual transformation
of a third-century prototype, a goddess naked to the waist,
through the late Hellenistic period to the fully garbed Victory
and finally to the Roman portrait statues, such as fig. 11,
largely copied from Greek models of gods and goddesses.[2]
In all three figures (9, 10, 11) the arm positions are the
same. The Capua Venus very possibly admired her reflection
in a large, polished metal shield. In the Brescia statue the
shield, along with wings, seems to symbolize Nike, the god-
dess of victory, inscribing a shield in a manner best known

[1]Personal communications to M. Del Chiaro from Dr. Evelyn
Harrison (Institute of Fine Arts, New York University)
and Dr. Brunilde Sismondo Ridgway (Bryn Mawr College)
during independent visits to the Santa Barbara Museum
of Art.

[2]See O. Broneer, "The 'Armed Aphrodite' on Acro-corinth
and the Aphrodite of Capua," *University of California
Publications in Classical Archaeology* 1 (1929–1944), pp.
65–84; G. Richter, "Who Made the Roman Portrait Statue,
Greeks or Romans?" *Proceedings of the Philosophical
Society* 95 (1951), no. 2, pp. 184–191; and M. Bieber,
Ancient Copies (New York, 1977), p. 43f. Also M. Bieber,
The Sculpture of the Hellenistic Age (New York, 1961),
p. 181 and figs. 673–677.

[3]See K. Lehmann-Hartleben, *Die Trajanssäule* (Leipzig,
1928), pl. 37; and F. Florescu, *Die Trajanssäule* (Bonn, 1969),
fig. 19 and pl. LXVI.

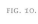 FIG. 10.

Marble; white, coarse-grained. Preserved height, approx. 1 m (approx. 3 ft. 3 in.). This is an incomplete torso which is greatly damaged and fractured. It is broken diagonally across the figure from the right waist to near the left breast and from the upraised knee of the left leg to the region of the right knee. There is evidence of much chipping at the edges of the folds of the drapery. Traces of modeled forms are seen in the much damaged and fractured statue support at the side of the right leg. A small pinhole (approx. 5 mm in diameter and 3 cm deep) can be seen in the heavy drapery (mantle) at the left hip.

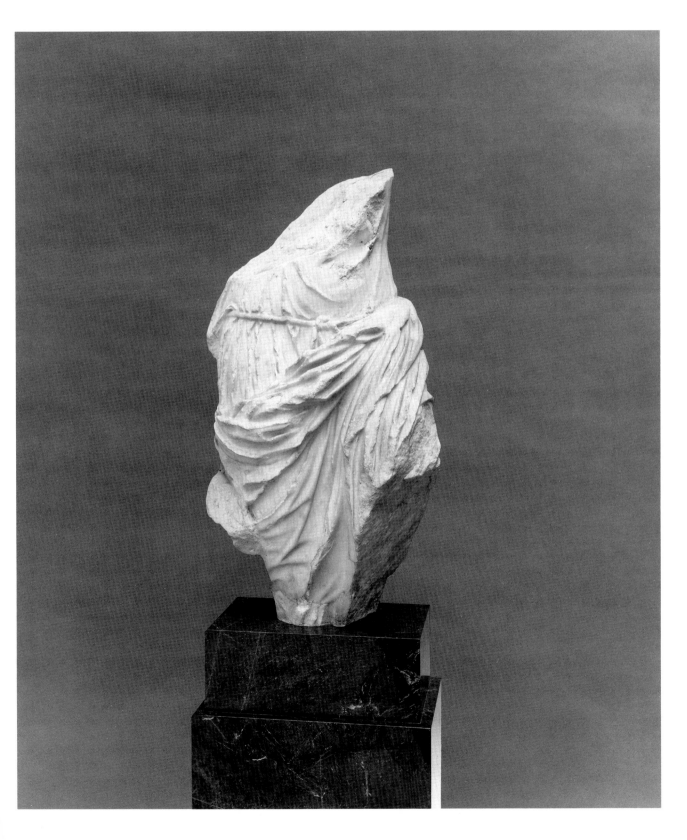

from the reliefs on the Column of Trajan in Rome.[3] A step further may be traced in view of the common Roman practice of using Greek statues of gods or goddesses as models for certain portrait statues[4]— doubtlessly at the request of the Roman client. A good case in point is the group statue type portraying Venus and Mars, specifically, in some instances, the emperor and his empress as the godly lovers (fig. 11).[5]

It is impossible to know whether the Santa Barbara torso was originally a single piece of sculpture or part of a group. The small hole in the mantle on the left thigh could have been made to stabilize a metal shield, as in the Brescia Victory, or — though this is less likely because of the full drapery — a mirrored shield, as in the Capua Venus viewing her reflection. It is also possible that the hole held a pin fixed to a musical instrument or scroll and that the Santa Barbara draped torso represented one of the nine Muses who normally accompanied the Apollo Musegetes in theaters.[6] Still another possibility, perhaps much less likely than the preceding ones but intriguing, is suggested by close examination of the extant portion of the statue-support barely visible at the right leg of the torso. On this support there is a worked surface, convex in shape, suggesting perhaps a tree trunk (branch?), part of an Eros, or the tapered portion of a dolphin (near the tail?) — all of which were commonly used as statue-supports.[7] The surface seems too smooth and lacking in texture for a branch, however, and there is little suggestion of anything like human anatomy. A dolphin, sometimes associated with Aphrodite, is certainly possible.[8] Also, if one views the convex section as part of the

body of a snake, there is a further possibility that the Santa Barbara torso represented the goddess Hygeia (personification of Health), who was associated with the cult of Asklepios, and Hygeia is frequently shown in statues with a coiled snake.[9]

In its size and dimensions as well as in its pose and the complexity of the folds of the drapery, the Santa Barbara figure is very similar to a headless and armless draped figure in Madrid.[10] The Madrid Venus is double-belted — that is, she wears one belt near the waist and another just below the breasts. This same feature could have been present on the lost upper portion of the Santa Barbara torso, but there is no evidence for such a possibility.

[4]Bieber, *Sculpture of the Hellenistic Age*, p. 181.

[5]For another portrait statue, with an empress more akin to the Venus of Capua, see R. Brilliant, *Roman Art* (London, 1974), p. 177: Commodus and Crispina; and Bieber, *Ancient Copies*, pl. 20, figs. 107–109.

[6]Brilliant, figs. 44, 45, 499, 501, 504. See also C. Vermeule and N. Neuerburg, *Catalogue of the Ancient Art in the J. Paul Getty Museum* (1973), nos. 39–41; G. Lippold, *Die Skulpturen des Vaticanischen Museums*, III, 1 (Berlin, 1936), pls. 4, 7, 8, 10.

[7]See the Naples Doryphoros (fig. 3); also the Medici Venus, Bieber, *Sculpture of the Hellenistic Age*, figs. 30, 31; and G. Hanfmann, *Roman Art* (New York, 1964), pl. 50.

[8]Hanfmann, pl. 50. See also A. Blanco, *Museo del Prado. Catalogo de la Esculture* (Madrid, 1957), pls. XV and XVII, 33-E; Vermeule and Neuerburg, no. 32.

[9]See S. Reinach, *Répertoire de la statuaire grecque et romaine*, vol. 2 (Paris, 1904), p. 37, nos. 5 and 6. Also Vermeule and Neuerburg, no. 42.

[10]Blanco, no. 33-E, pls. XV and XVII.

12.
Aphrodite (or Nymph)[1]
Roman statue of the 1st century B.C. based on a 3rd-century
Greek type
1973.52
Gift of Wright S. Ludington

The slim, lithe figure and high, firm breasts of this super-
lative statue identify it almost assuredly as an Aphrodite or
nymph. The graceful and voluptuous young woman
stands with her upper body bent gently forward and slightly
tilted to the right, her weight primarily borne by the left
leg, the right seemingly more advanced than the left. Though
it is curiously reminiscent of the work of seventeenth-
century Mannerists in the elongated elegance of the torso,
it is without any doubt a product of classical antiquity.
Were the right shoulder somewhat lower, one might specu-
late that she was in the familiar classical pose of stooping
to adjust her sandal.[2] One can only guess what the support
may have been or just how the right hand and lower arm
were held. The head undoubtedly tilted to the right, in a
curve that completed the curve of the torso. Even with the
head missing, the beautiful upward movement to the
figure's left side is impressive, viewed from any angle. Seen
from the front, the reverse curve of the drapery hanging
over the left arm is a strong counter to the curve and motion
on the right side. The left hand must have grasped the end
of the drapery that comes up across the right thigh.[3]

The modeling of the body subtly conveys the sensuality
that one associates with the goddess of love, or with a
nymph. Even in its present state — and the marble was no
doubt once highly polished — the skin appears rounded
and soft. Note particularly the pronounced dimples above the
buttocks, the deep navel, and the bulge of the *mons
veneris* set off by the deep crescent crease above.[4] The
sensuousness of the figure is perhaps most striking in left
profile, where the rich, heavy folds of the mantle swirling
around the back of the body over the buttocks and up over
the left forearm accentuate the subtle, somewhat hesitant
forward tilt of the torso. The linear quality of the folds,
which are richly undercut to create deep shadows, emphasizes
the sensuousness of the pose. As in nos. 10 and 11, the
rippling patterns and the deep undercutting illustrate the
concern with the play of light and shadow in drapery
forms during the late Hellenistic period.

41

[1]C. Vermeule, *Greek and Roman Sculpture in America*
(Berkeley, 1981), no. 142, p. 175, where assigned to "Late
Hellenistic."

[2]For this pose see M. Bieber, *The Sculpture of the Hellenistic
Age* (New York, 1961), figs. 394 and 395.

[3]See S. Reinach, *Répertoire de la statuaire grecque et
romaine*, vol. 1 (Paris, 1897), p. 322, no. 8; and G. Richter,
*Catalogue of Greek Sculptures in the Metropolitan Museum
of Art* (Cambridge, Mass., 1954), no. 150, pl. CIX.

[4]These features are conspicuously present on the Aphrodite
from Alba Fucens: see V. Cianfarani in *Bollettino d'Arte*
36 (1951), pp. 246-247.

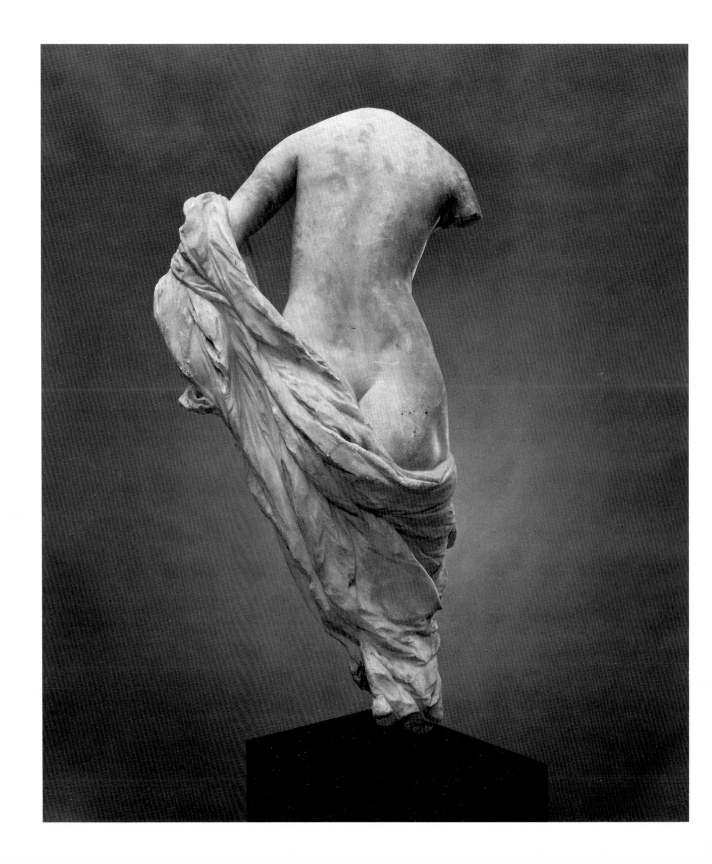

Marble; white, fine-grained. Preserved height, approx. 1 m (approx. 3 ft. 3 in.). The head is broken from the neck and now lost. The right arm is missing from below the deltoid, the left preserved from the shoulder to the mid-forearm. The lower parts of the legs are lost: from the lower thigh of the left leg and from the area of the knee of the right. The heavy drapery (mantle) is broken and missing near the upper left thigh and at a point below the broken left arm where it would have ended. A broken circular spot on the drapery on the right indicates an original strut, presumably to a support. Minor abrasions, encrustation, and discoloration are apparent at scattered points. Clear marks of the claw chisel can be seen on the torso behind the right arm and near the breasts.

43

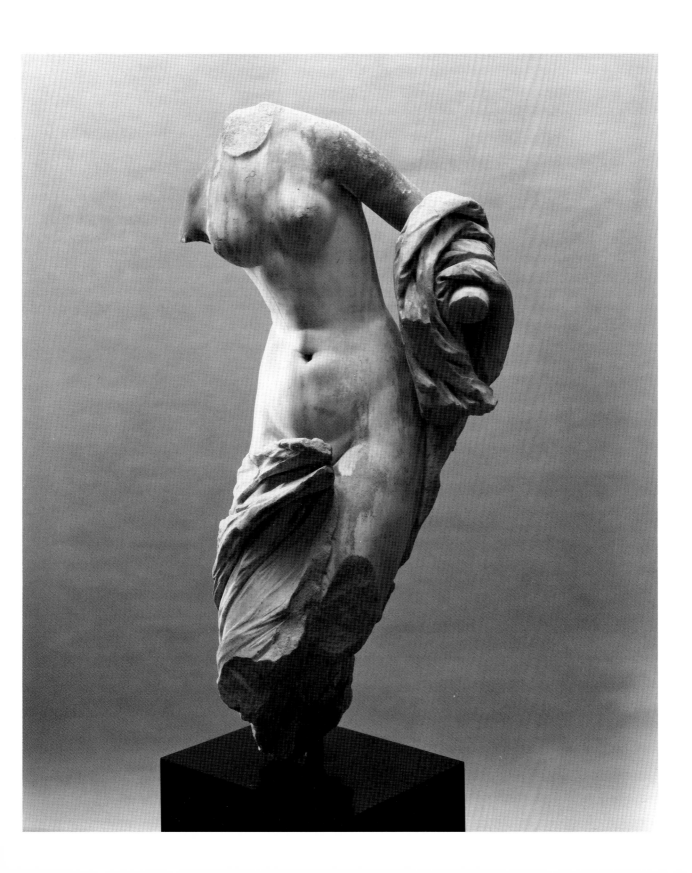

FIG. 12.

13.
Head and Torso of Aphrodite
Roman copy (Antonine: 2nd century A.D.?) after a Hellenistic type
based on a Praxitelean prototype
1978.4.10
Gift of Wright S. Ludington

44

From the extant portions of this statue, evidently an Aphrodite, it can be surmised that she stood with her weight on her right leg, the left relaxed, with the head and torso turned slightly to the right. The Capitoline Venus (fig. 12), among numerous statues of a similar type, suggests that the Santa Barbara statue stood with one arm — probably the left, since she turns her head to the right — bent across her breast and with the right arm extended to grasp the drapery around her thighs and legs. The ridge or carinated lip still present at the hips of the torso where it fits into the modern socle is strong evidence that the figure was originally created in parts rather than carved in one piece, with the torso set into the lower, mantled portion. This technique was not uncommon and is indeed that of the celebrated Venus of Melos in the Louvre.[1] Although the slim Santa Barbara Aphrodite bears some resemblance to the riper figure of the Venus of Melos in the rendering of the anatomy, particularly in the hips and stomach, she more closely resembles a very fragmentary torso known as the Ince Hall Aphrodite, in which one sees a similar treatment of the *mons veneris* as well as of the stomach and hips.[2]

The distinctive coiffure of the Santa Barbara Aphrodite combines features from two well-known representations of the goddess: a similar topknot appears on the Capitoline Venus (fig. 12), and the bun is very much like the one of the Medici Venus.[3] This is not to say that these were the source of inspiration, for the topknot appears on numerous heads, as in the Bartlett Head in Boston (fig. 13),[4] but the type of coiffure and, especially, the manner in which it was carved,

with heavy use of the drill, are particularly helpful in placing the Santa Barbara Aphrodite torso in its proper chronological framework. The drilling technique is a strong indication that the work was created during the Antonine period (A.D. 138–192), when excessive drilling to attain a conspicuous contrast of texture and light and dark was much in vogue.

A striking feature of the face is the filmy or *sfumato* (smoky) quality of ordinarily harsh lines, such as in the softening at the edges of the eyelids. This stylistic technique was introduced by Praxiteles (Hermes and the Infant Dionysos) and became extremely popular with his followers (see the Bartlett Head, fig. 13, and the Warren Head or "Maiden from Chios," also in Boston).[5] The *sfumato* effect in the head of the Santa Barbara Aphrodite may be a modern addition, however.

[1]See J. Charbonneaux, *Le Vénus de Milo, Opus Nobile, Meisterwerk der Antiken Kunst*, vol. 6 (Bremen, 1958). See also M. Bieber, *The Sculpture of the Hellenistic Age* (New York, 1961), figs. 673–675.

[2]See B. Ashmole, *A Catalogue of the Ancient Marbles at Ince Blundell Hall* (Oxford, 1929), fig. 63.

[3]Bieber, figs. 28, 30, 31.

[4]E.g., B. Maiuri, *The National Museum, Naples* (Novara, 1959), pp. 38–39; C. Vermeule and N. Neuerburg, *Catalogue of the Ancient Art in the J. Paul Getty Museum* (1973), no. 32.

[5]Vermeule and Neuerburg, figs. 11 and 12; L. Caskey, *Catalogue of the Greek and Roman Sculpture*, Boston Museum of Fine Arts (Cambridge, Mass., 1925), nos. 28 and 29. See also G. Richter, *The Sculpture and Sculptors of the Greeks* (4th ed.; New Haven, 1970), figs. 182–183; M. Comstock and C. Vermeule, *Sculpture in Stone* (Boston, 1976), nos. 55 and 56.

Marble; white, coarse-grained. Height, approx. 61 cm (approx. 2 ft.).
Both arms are missing, but cuttings, metal dowels, and subsequent staining at the
areas of the armpits suggest that the arms may have been added separately in
the original. Although the modern socle or socketed base hides the original
"setting" of the torso into a mantled lower portion, a "lip" or ridge is still visible
at the right hip and along the back of the left hip. The tip of the nose is missing.
The surface of the face and hair is extremely worn and shows signs of reworking.
Heavy brownish encrustation is present in the hair, on the face, and on parts
of the torso, some of which has apparently been removed.

45

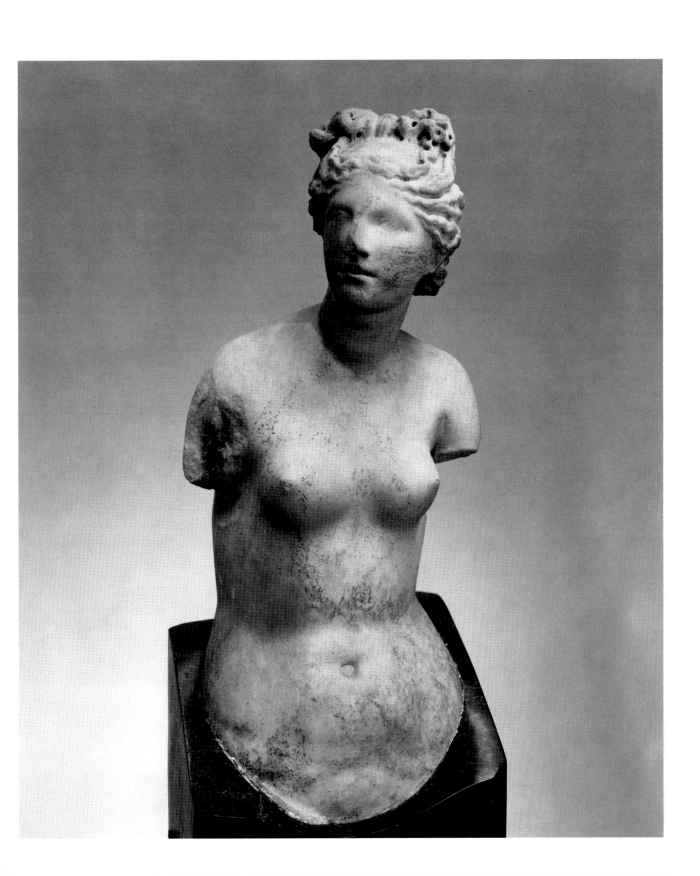

14.
Torso of Aphrodite
Roman version of a Greek original in the 4th-century B.C.
Praxitelean tradition.
1949.16
Gift of David Burgess in memory of Lockwood de Forest

FIG. 21.

46

Although a far cry from the slender and graceful Praxitelean
prototype suggested by this relatively small Aphrodite
statue, its stance with legs originally parted and one ever so
slightly advanced, tilt of the torso, and extant portions of
the arms reveal an active pose recalling an Aphrodite type
that shows the goddess putting on a necklace or a *stephane*
(diadem), or arranging her hair as she holds a mirror,
perfume vase, or the like. An original bronze statuette dating
to the fourth century B.C. in the British Museum (fig. 21)[1]
provides an excellent example of the type, for which
numerous variations are known.[2]

The statue type served equally well for the Aphrodite
Anadyomene (emerging from the sea, alluding to the
goddess' birth), for which she is generally shown wringing
sea-foam from long tresses of her hair.[3] At the break of the
right leg, traces of drapery have survived to indicate that,
not surprisingly, a statue-support — possibly a tree trunk or
some similar brace — over which a garment was draped
was located near and against the leg.[4]

[1]See G. Richter, "Two Bronze Statuettes," *American Journal
of Archaeology* 37 (1933), pp. 48–51 and pls. VI–VIII.

[2]M. Bieber, *The Sculpture of the Hellenistic Age* (New
York, 1955), figs. 37, 38, and 39. See also E. Paribeni,
Catalogo delle sculture di Cirene (Rome, 1959), pl. 134,
nos. 274, 275, 276, and 278.

[3]Bieber, fig. 37. See also D. Brinkerhoff, *Hellenistic Statues
of Aphrodite* (New York, 1978), chap. 3 and pls. XXXV,
XL–LI; G. Richter, *Catalogue of Greek Sculpture in the*

Metropolitan Museum of Art (Cambridge, Mass., 1954),
nos. 152–155, pls. CX–CXII.

[4]Cf. Richter, *Catalogue*, no. 157, pl. CXIII. For a particularly
fine example of the statue type with support drapery at
the same point of the right thigh, see the "Aphrodite from
Cyrene": Brinkerhoff, pls. XLIII–XLIV; W. Fuchs, *Die
Skulptur der Griechen* (Munich, 1969), p. 244, fig. 267; and
A. Giuliano, ed., *Museo Nazionale Romano. Le sculture*
I.1 (Rome, 1979), no. 115, p. 175.

Marble; white, fine-grained. Preserved height, 40.5 cm (approx. 16 in.).
The figure is headless and armless. The left arm is partially preserved to the
mid-upper arm. There are holes at the stump of the arms from previous repairs;
with a metal tenor yet embedded in left arm. The legs are preserved to about
mid-thigh or less. There are clear signs of an attempt to remove the extensive root-
marks, particularly at the breasts. These root-marks therefore appear somewhat
flattened in the abdomen, stomach, and hip areas.

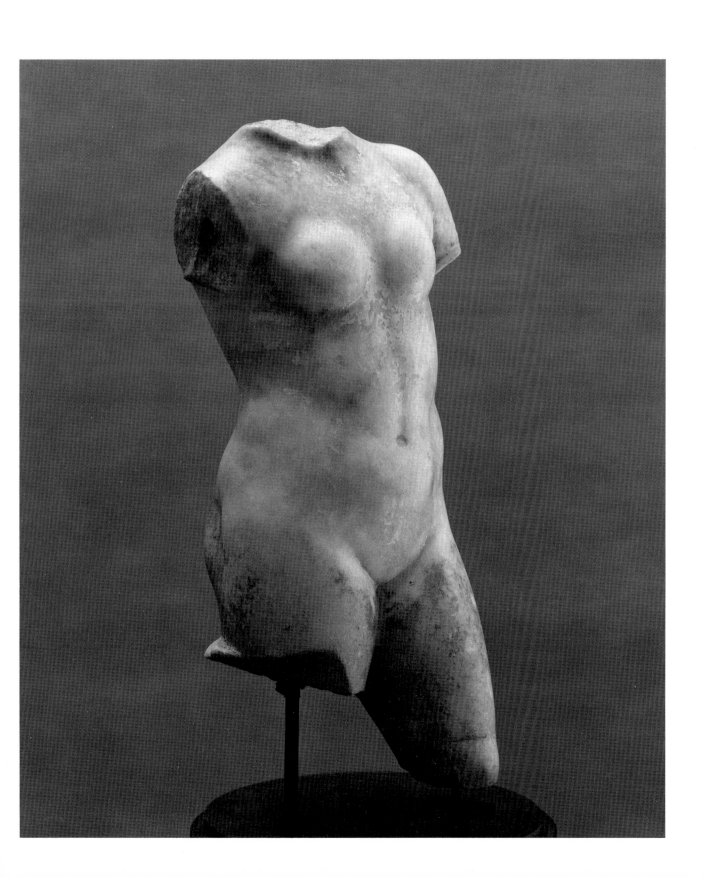

15.
Head of Aphrodite
Roman copy (Antonine: 2nd century A.D.?) after a Hellenistic type
based on a Praxitelean prototype
1978.4.9
Gift of Wright S. Ludington

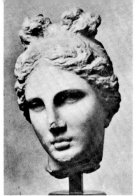

FIG. 13.

48

This slightly under life-size head of Aphrodite may
originally have been part of a statue not unlike the draped
Aphrodite (no. 13). The very noticeable heavy drillwork
in the coiffures of both heads is a good indication that both
pieces date from the Antonine period. Again, there is an
affinity with the Bartlett Head (fig. 13), though the Santa
Barbara head has a more downward tilt and a perhaps
more bemused, less pensive expression. Other typological
and stylistic analogies to be noted are an example in Madrid[1]
and another in Budapest.[2]

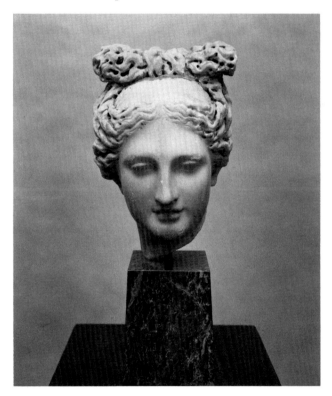

[1] A. Blanco, *Museo del Prado. Catalogo de la Esculture*
(Madrid, 1957), no. 44-E, pl. XXXII, which, Blanco points
out, shows an Aphrodite head placed directly on the
body of "Calliope" (see p. 41 f.).

[2] A. Hekler, *Die Sammlung Antiker Skulpturen* (Budapest,
1939), p. 49.

Marble; white, coarse-grained. Height, 29 cm (approx. 11½ in.).
The piece has an oblique break at the neck. The topknot was once broken away
but has been reattached. There has been considerable drillwork throughout
the hair. There are signs of much reworking of the surface-polishing, recutting,
etc. — particularly in the central area of the hair, eyes, nose, and the corners
of the mouth.

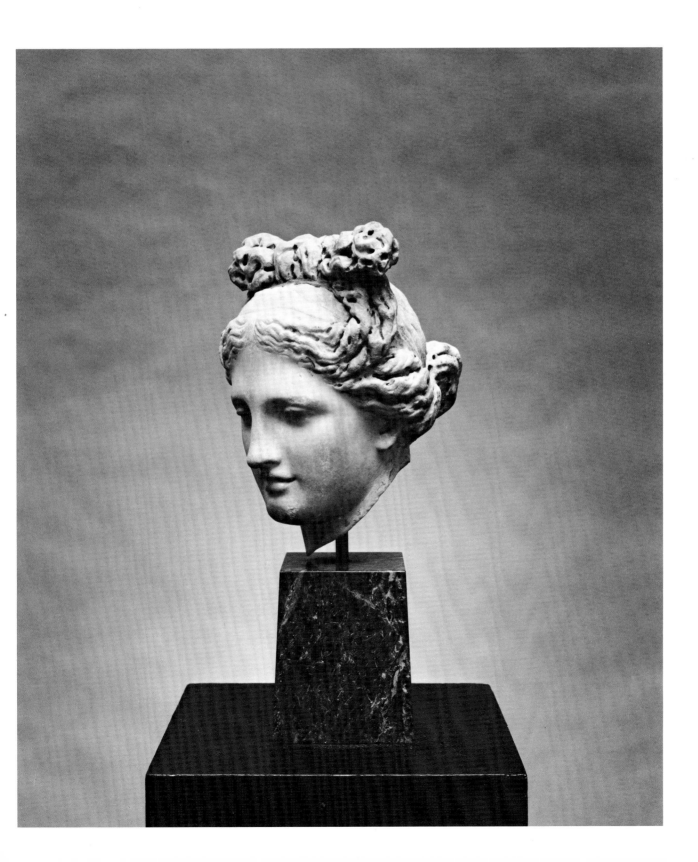

16.
Satyr and Nymph[1]
Roman copy (mid-2nd century A.D.?) of a Hellenistic original of
the 2nd century B.C.
1978.4.8
Gift of Wright S. Ludington

This statue of a frolicking satyr and nymph exemplifies a
subject popular during the Hellenistic period and testifies to
the Hellenistic interest in subjects seldom attempted in the
sculpture of earlier periods. The prototype probably
originated in Asia Minor. Since it is known in a number
of replicas and fragments, we can reconstruct the full pose
and action of the Santa Barbara Satyr and Nymph with a
fair degree of certainty.[2]

The satyr, traces of his tail still visible at the small of
his back, sits on a stump or rock covered by the skin of a
goat, the masklike head of which peers out from under the
satyr's right knee. Between the satyr's widespread legs, a
nymph tries to escape his lascivious grasp, but the satyr pre-
vents her flight by locking her left foot with his right ankle.
The nymph twists sharply to look back at the satyr as she
pulls at his hair with her extended right hand.[3] At the same
time, she attempts to remove his right hand from her breast
with her now missing left hand. The upward tilt of the
satyr's right shoulder suggests that he may have been trying
to seize the hand as she pulls at his hair.

Even though the complete pose has to be filled out in
one's imagination, this pair is a fine example of the complex
interwoven composition of late Hellenistic statue groups.

[1]C. Vermeule, *Greek and Roman Sculpture in America*
(Berkeley, 1981), no. 131, p. 164 where the author mentions
F. Causey Frel's observation that a head in the Rhode
Island School of Design, Providence (Inv. no. 26.165) —
ibid., no. 132, p. 165 — may actually belong to the Santa
Barbara satyr.

[2]Rome, Museo Nazionale, R. Paribeni, *Le Terme di
Diocleziano e il Museo Nazionale Romano* (2nd ed.; Rome,
1932), no. 172; W. Helbig, *Führer durch die öffentlich
Sammlungen klassicher Altertümer in Rom*, vol. 3
(Tübingen, 1969), pp. 59–60, no. 2157; and J. Charbonneaux
et al., *Hellenistic Art* (New York, 1973), p. 316, fig. 349.
Naples, Museo Nazionale, Raccolta pornografica, no.
RP 152873, M. Grant, *Eros in Pompeii: The Secret Rooms of
the National Museum of Naples* (New York, 1975),
p. 86f. Paris, Musée du Louvre, S. Reinach, *Répertoire de la
statuaire grecque et romaine*, vol. 2 (Paris, 1904), p. 63,
no. 5; *Encyclopédie photographique de l'art*, vol. 3 (Paris,
1938), pl. 239; and J. Charbonneaux, *La sculpture grecque
et romaine au Museé du Louvre* (Paris, 1963), p. 85,
no. 248. Rome, Ludovisi Collection, Reinach, vol. 2, p. 147,
no. 5; Helbig, vol. 3, p. 60. Rome, Museo Torlonia, C.
Visconti, *I Monumenti del Museo Torlonia* (Rome, 1884),
no. 7, pl. 2. It should be noted that the illustration of the
Santa Barbara Satyr and Nymph published in the
Classical Journal 60 (1964), p. 119, fig. 10, is reversed.

[3]M. Bieber, *The Sculpture of the Hellenistic Age* (New York,
1961), figs. 626, 627. See also D. Brinkerhoff, "New
Examples of the Hellenistic Statue Group, 'The Invitation
to the Dance,' and Their Significance," *American Journal of
Archaeology* 69 (1965) pp. 25–38. See also B. Ridgway,
*Catalogue of the Classical Sculpture in the Rhode Island
School of Design* (Providence, 1972), no. 23, and figs. 5–7
on p. 180 for the similar Satyr and Nymph in Rome
(Museo Nazionale Romano) and Paris (Musée du Louvre).

Marble; white, coarse-grained. Preserved height with plinth, 1.16 m (approx.
3 ft. 9½ in.); height of plinth, 12 cm (4¾ in.); diameter of plinth, approx. 50 cm
(approx. 19¾ in.).
The head, right arm, and part of the penis of the satyr are missing; a dowel hole at
the stump of the right arm indicates some attempt at restoration. The head, most of
the right arm, and the left hand of the nymph are missing. Though there are numerous
fractures, modern restorations are few and readily recognized by the difference in
the stone which is smoother and whiter. Note the right calf of the satyr, the nymph's
right ankle and a wedge-shaped section at the back of the left arm above the elbow.
Considerable chipping occurs throughout, but especially on the right breast of the
nymph and on the right knee and tail of the satyr. The surface of both figures shows
many pits and abrasions as well as encrustations and discoloration.

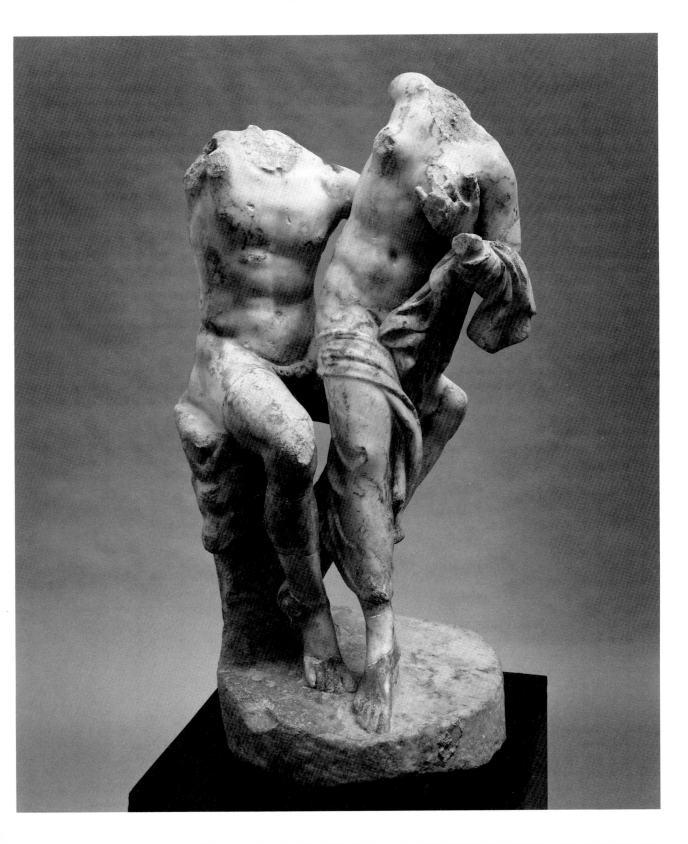

17.
Archaistic Female Head
Roman; possibly late 1st century B.C. Archaistic head from a herm.
1973.72
Gift of Wright S. Ludington

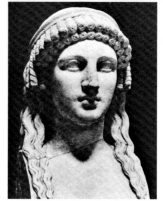

FIG. 14.

52 This archaistic head, with a face that is pleasingly asymmetrical (the left eye longer and slightly lower than the right, the right cheek fuller than the left, and the left corner of the slightly parted mouth higher and farther from the center than the right corner), is marked by an eclecticism of style, perhaps heightened by some reworking in modern times. The eyebrows, nose, facial planes, and especially the flat forehead are characteristic of the Classical style of the fifth century; the mouth and lips are more indicative of the fourth century or later; the hair is astonishingly Archaic. Eclectic sculpture of this sort, which included Archaic features, was present in the late Hellenistic period in the work of Pasiteles and his school (first century B.C.) and became especially popular in Roman sculpture during Augustan and even later Imperial times.[1]

The Santa Barbara Archaistic Head may well have been made to crown a herm. This possibility is suggested by the similarity of the coiffure to those of three herms, including one at Ince Blundell Hall in England (fig. 14), the only difference being the ornamental diadem on the Santa Barbara head instead of a narrow fillet.[2] These other heads (two of the double herm type) all have long locks of wavy hair (preserved only in part at the right side of the Santa Barbara head) that sweep over the ear, below the corkscrew curls, and down over the shoulders. Herms were especially in vogue in the first century B.C., and if the Santa Barbara Archaistic Head was originally on a herm, it probably can be assigned to that period rather than to later Roman times.[3]

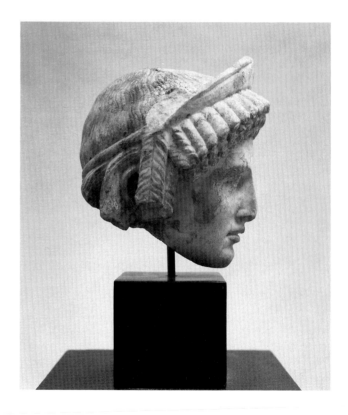

[1]See G. Richter, *Ancient Italy* (Ann Arbor, 1955), and M. Bieber, *The Sculpture of the Hellenistic Age* (New York, 1961), p. 181f. See also M. Borda, *La Scuola di Pasiteles* (Bari, 1953). A bronze herm in Tunis with a bearded Archaic head of Dionysos, once part of a statue composition, has been attributed to the sculptor Boethos, active during the first half of the second century B.C.: see Bieber, figs. 286 and 288; Richter, *The Sculpture and Sculptors of the Greeks* (4th ed.; New Haven, 1970), fig. 821, and p. 182; and C. Vermeule, *Greek and Roman Sculptures in America* (Berkeley, 1981), nos. 156–157, pp. 190–191.

[2]B. Ashmole, *A Catalogue of the Ancient Marbles at Ince Blundell Hall* (Oxford, 1929), no. 119; G. Lippold, *Die Sculpturen des Vaticanischen Museums*, III, 2 (Berlin, 1956), pl. 207, no. 35, and pl. 209, no. 41. Add to these an especially close unpublished specimen in Rome: Museo Nazionale Romano (Terme), inv. no. 256893. See also, K. Fittschen, *Katalog der antiken Skulpturen in Schloss Erbach* (Berlin, 1977), no. 3 and pl. 4.

[3]The "Heyle Aphrodite" in Berlin is dated to mid-second century B.C.: C. Havelock, *Hellenistic Art* (Greenwich, Conn., 1971), pl. 97.

Marble; white, fine-grained. Height, 24.5 cm (approx. 9½ in.).
The head is broken away from the neck along the jawline. A large fragment is
missing from the left side, resulting in the loss of the ear and the row of cork-
screw curls at the temple. Some bad chipping is also present above the diadem at
the rght side, the right ear, and the ends of the curls in front of the ears. The
long tresses that sweep over the ear are broken off at the ends. The tip of the nose
is missing. There is much encrustation and discoloration. A drill has been used for
the corners of the mouth, the tear ducts, and in the flat ends of the corkscrew curls.

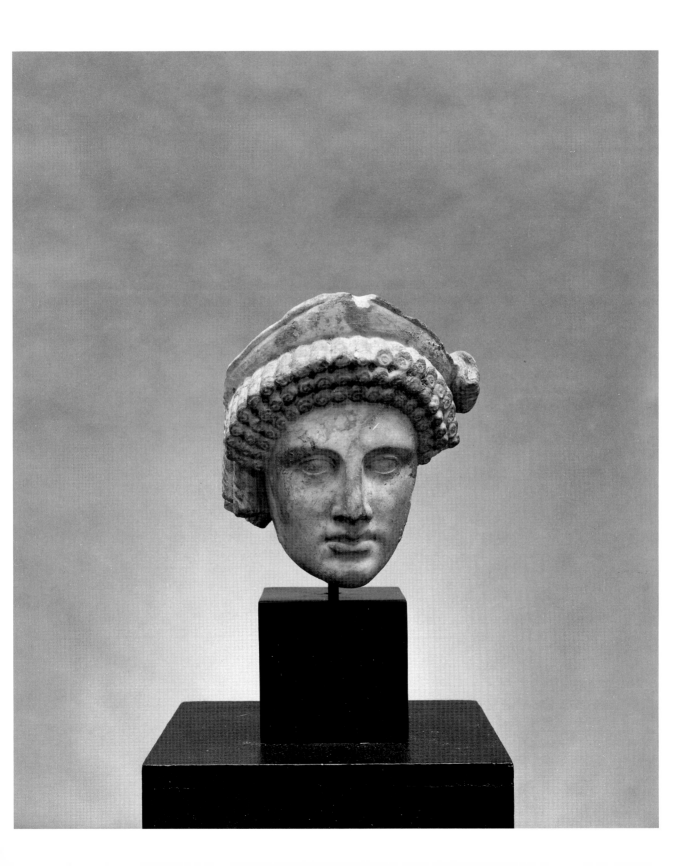

18.
Nude Torso of a Youth
Roman original of the 1st century B.C.
1978.4.4
Gift of Wright S. Ludington

FIG. 15.

The excellent condition of the surface of this life-size fragment makes it possible to observe and appreciate the sculptor's subtle modeling as well as his profound understanding of human anatomy. Also, though many statues preserved only as torsos give little or no clue to the original type or gestures, this torso fortunately has a few details which are of some help in a possible imaginative reconstruction.

At the lower edge of the torso, at the mid-abdominal area, there is a fold of flesh which suggests that the figure was bent forward at the waist, either seated or standing in a crouched position. A goodly number of extant statues of nude youths seated (as in fig. 15), crouched, or in some variant pose, offer prototypes.[1] From the preserved portions of the arms and neck in the Santa Barbara torso it can be surmised that the right arm extended downward; if the figure was seated, the hand may have rested on a rock (cf. fig. 15), or the forearm may have rested on the right thigh.[2] The upward tilt of the left shoulder as well as the character of the trapezius muscle, represented by the V-shaped break below the stump of the left arm, shows that the left arm was sharply upraised. From what remains of the neck, we can infer that the head was turned to the left, perhaps tilted slightly upward toward the upraised left arm.

All these features — folds at the abdomen or waist, lowered right arm, upraised left arm, and head turned to the left — are to be found in one or more existing statues, but not all of them in any single statue.[3] One small, very inconspicuous detail of the Santa Barbara torso may suggest an additional possibility. This clue is a small, barely discernible ridge or matrix located at the very edge of the break of the upraised left arm at the upper deltoid, which could suggest a bit of drapery belonging to a *chlamys* (short cloak) that was thrown over the arm and shoulder. Such a cloak might associate this torso with a statue type that has been variously identified as Narcissus or a youthful Dionysos (though the type is normally a standing statue and lacks fleshy folds in the lower abdominal region).[4]

Although it cannot be conclusively stated that the Santa Barbara Nude Torso of a Youth was originally seated or crouching, it does seem highly probable that it may have represented a seated youth somewhat akin to the bronze Hermes from Herculaneum in Naples (fig. 15), but with the right arm upraised, the hand perhaps holding a spear or a staff or some similar object. The sensitivity of the modeling of the torso to create a soft play of light and shadow is strongly in the Praxitelean tradition, and on this basis alone — though we lack an exact parallel at this time — we can conclude that the torso is an original work of the first century B.C.

[1]S. Reinach, *Répertoire de la statuaire grecque et romaine*, vol. 1 (Paris, 1897), pp. 244, 316; C. Picard, *Manuel d'archaéologie grecque, la Sculpture IV siècle* (Paris, 1948), fig. 243; M. Bieber, *The Sculpture of the Hellenistic Age* (New York, 1961), figs. 103–111.

[2]A. Lawrence, *Later Greek Sculpture* (New York, 1969), pl. 13; Bieber, fig. 149.

[3]Reinach, vol. 1, pp. 137, 316; Lawrence, pls. 15, 32; Bieber, figs. 431, 448. An especially provocative possibility may be found in one of the sons (right-hand side) in the celebrated Laocoön statue group; see G. Richter, *The Sculpture and Sculptors of the Greeks* (4th ed.; New Haven, 1970), fig. 831.

[4]Bieber, figs. 109–111; Richter, fig. 847. Folds of flesh are present in the abdominal area in the copies of Myron's Discobolos (see Richter, figs. 578–581), but the body has a violent twist, quite unlike the Santa Barbara torso.

Marble; white, possibly Parian. Preserved height, 42.5 cm (approx. 16¾ in.). Missing are the head from the lower neck, the left arm from the shoulder, the right arm from just below the deltoid, and the remainder of the body from the waist on down. The bright white marble is only slightly marred by scratches and abrasions and by minor encrustation and discoloration. There are no signs of restoration.

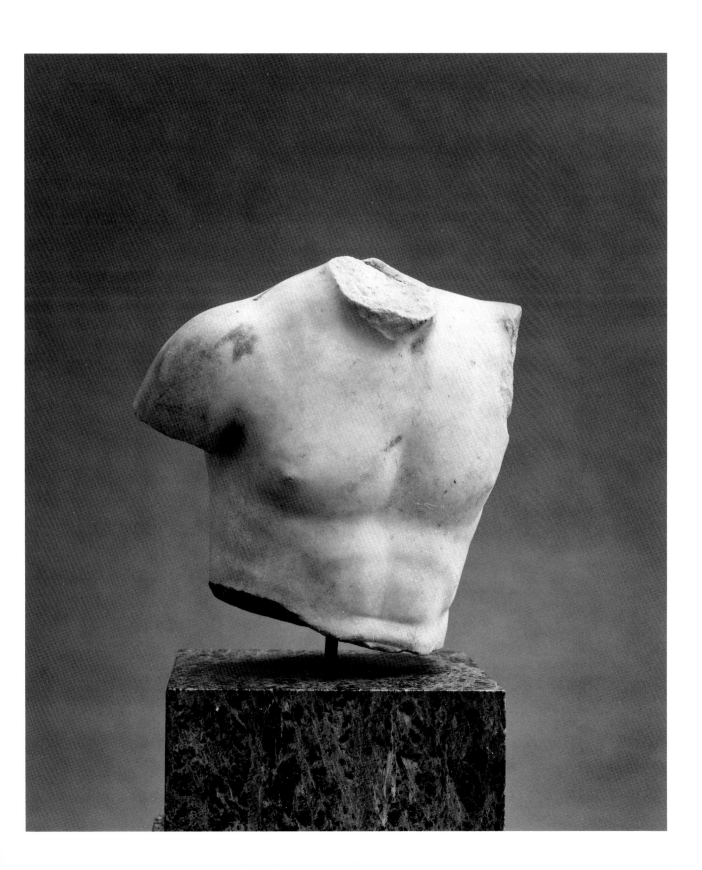

19.
Head of a Horse
Roman. Probably 1st century A.D.
1978.4.11
Gift of Wright S. Ludington

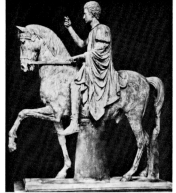

FIG. 16.

FIG. 17.

56

This nearly life-size equine head shows nervousness and vitality in the careful treatment of flesh, muscles, veins, and sinews, all characteristic of the late Hellenistic sculptural style. It seems likely that the jaws were open. The completeness of the modeling on both sides of the head is persuasive evidence against its having been part of a relief, although there are in existence several exceptionally high reliefs dating from the Hellenistic period, such as the Altar of Zeus at Pergamon. Nonetheless, stylistic parallels for the horse type can be found in a number of Hellenistic reliefs.[1] Some reliefs thought to be from Asia Minor have horses of an especially striking similarity as well as rather similar trappings.[2] The oval ornament on the horse's nose, with a raised longitudinal spine or ridge, was particularly popular in Asia Minor. An appropriate illustration of the type is provided by a fine bronze statuette discovered at Herculaneum (fig. 16) representing Alexander the Great, probably riding his favorite mount, Bucephalus. This statuette has stylistic analogies with the Santa Barbara head not only in the trappings but also in the modeling.

Both the scale and the careful carving in the round are good evidence that the Santa Barbara Horse Head probably belonged to a full-scale marble equestrian statue of a type not uncommon in Roman art during the late Republic and early Imperial periods. A noteworthy example of the type is the equestrian statue of Nonius Balbus (dating to the first century A.D.) discovered at Herculaneum and presently in the Museo Nazionale, Naples (fig. 17).[3] Since few examples of ancient horse trappings have survived, the Santa Barbara head provides another good source for scholars interested in the horsemanship of classical antiquity.[4]

[1] On a relief in Athens with horse and groom, see V. Kallipolitos, *Museo Nazionale, Atene* (Novara, 1970), no. 153.

[2] The horse of Helios on the frieze from the Altar of Zeus at Pergamon: see E. Schmidt, *The Great Altar of Pergamon* (Leipzig, 1962), pls. 21, 22. On the Amazonomachy reliefs from the Temple of Artemis, Magnesia on the Meander, see J. Charbonneaux et al., *Hellenistic Art* (New York, 1973), fig. 306.

[3] F. Consoli, *National Museum of Naples: The Archeological Collection* (Naples, 1938), fig. 2; T. Kraus, *Das Römische Weltreich, Propyläen Kunstgeschichte*, vol. 2 (Berlin, 1967), pl. 295.

[4] See, e.g., J. K. Anderson, *Ancient Greek Horsemanship* (Berkeley, 1961); S. D. Markman, *The Horse in Greek Art* (New York, 1969).

Marble; white, fine-grained. Preserved length, 48 cm (19 in.); maximum height, 38.5 cm (15 in.).

The head is broken from the base of the cheek diagonally across to the back of the neck. The ears are missing, as is the entire nose or muzzle from near the beginning of the mouth. All the broken areas have been smoothed over and further worked with a pointed chisel in preparation for restoration, signs of which are present in the dowel holes set into the smoothed areas. Behind the ears a square metal dowel is still visible. Parts of the birdle have been chipped away and repaired. The rosette at the left cheek is a restoration. Some pitting and abrasions are present throughout the surface.

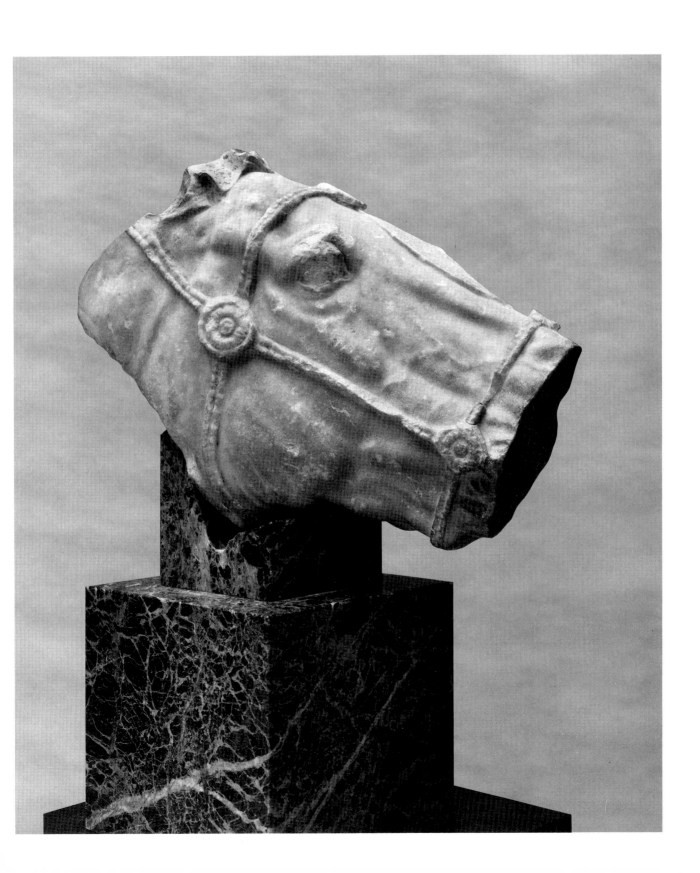

20.
Dioscurus (Castor or Pollux)
Roman. 1st or 2nd century A.D.
1978.4.12
Gift of Wright S. Ludington

Even with the great amount of restoration, including the clumsy work on the feet and the "Michelangelesque" right hand, this small statue is a typical and useful example of a sculptural type of which the Romans were particularly fond. The Romans very likely adopted the Dioscuri (Greek Dioskouroi) — the twins Castor and Pollux (Greek Polydeukes), minor divinities — from the Greeks by way of the Etruscans, and they put them to use in various roles. Most often they were patrons of the soldier and sailor,[1] but they were also renowned horsemen, and the horse frequently accompanies them in both sculptural and numismatic representations.[2] In the Santa Barbara Dioscurus, the horse is present as a protome springing forth from an acanthus. (The slight projection of both the acanthus and the restored right foot beyond the plinth clearly demonstrates that the plinth has been recut to fit into the new socle.)

Very similar drapings of the chlamys around the neck and over the upraised arm are to be found on a relief of the Dioscuri in Rome[3] and on a fragmentary headless torso (with missing upraised arm) at Cyrene, the latter very close in scale to the Santa Barbara counterpart.[4] One of the figures on the relief has the upraised arm grasping a spear, held vertically, the tip of which rests on the ground. The Santa Barbara Dioscurus may well have been similarly equipped. Since the Dioscuri were usually represented as a pair, he can reasonably be supposed to have had a twin, perhaps in reverse pose.[5]

[1]C. Daremburg and E. Saglio, *Dictionnaire des antiquités grecques et romaines,* vol. 2 (Paris, 1877; reprinted Graz, 1962), pp. 253f.

[2]R. Bianchi Bandinelli, *The Buried City: Excavations at Leptis Magna* (New York, 1966), figs. 77–79; see also B. Maiuri, *The National Museum, Naples* (Novara, 1959), p. 22.

[3]A relief from the Altar of the Fountain of Juturna in the Roman Forum: see C. Picard, "La triade des Dioscures et d'Hélène en Italie," *Revue des études Latin* 17 (1939), pp. 389f.

[4]E. Paribeni, *Catalogo delle sculture di Cirene. Statue e rilievi di carrattere religioso* (Rome, 1959), no. 380, pl. 171. Preserved height, 32 cm.

[5]See, e.g., the monumental Dioscuri in the Piazza del Quirinale: T. Kraus, *Das Römische Weltriech, Propyläen Kunstgeschichte,* vol. 2 (Berlin, 1967), pl. 275.

Marble; white, fine-grained. Height of figure, 74 cm (approx. 2 ft. 5 in.); height with plinth, 79.5 cm (approx. 2 ft. 7½ in.).

The statue is much reworked and restored. The left arm from above the elbow and also the drapery of the mantle that hung from the left forearm are missing. The nose and muzzle of the horse, which serves as the statue-support, are missing. Much modern patching and rough plasterwork are present on the feet, parts of the left thigh, and the tip of the pointed hat *(pilus)*. The lower right forearm and sword hand are wholly modern, perhaps seventeenth or eighteenth century.

A considerable amount of surface scratches, abrasions, and retooling is found, especially on the face. The drapery around the neck shows evidence of recutting, and the plinth also has been recut, possibly reshaped, perhaps to fit into a socle.

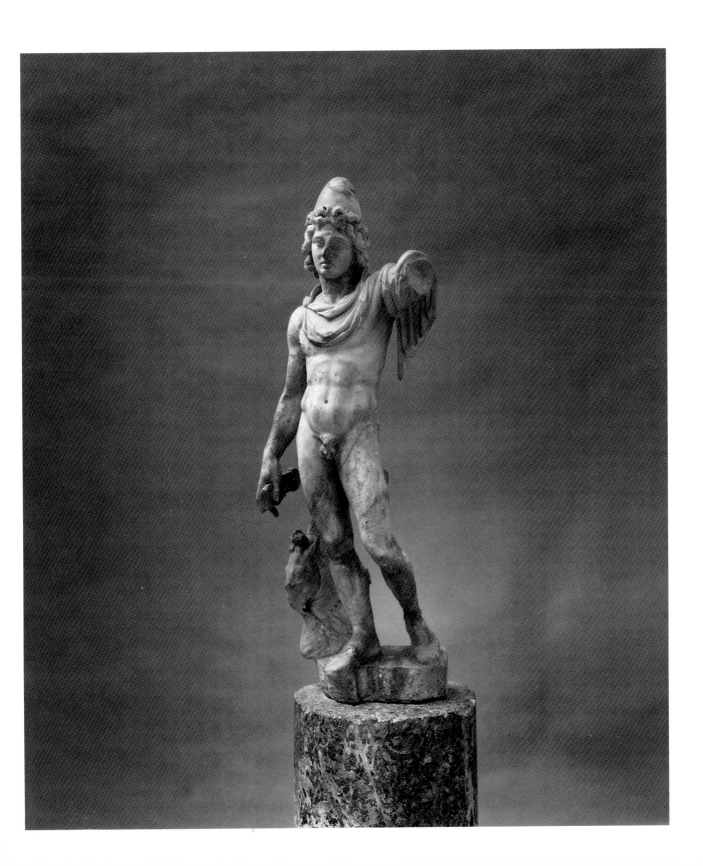

21.
Bearded Head[1]
Roman (Gallienic) portrait of an unknown Roman of about the
middle of the 3rd century A.D.
1971.51.2
Gift of Wright S. Ludington

This life-size bronze head, reportedly from western Asia
Minor, serves as a splendid example of the standing portrait
statues that were popular in Roman times, especially in the
late Imperial period.[2] The serrated lower edge of the neck
probably indicates that the head was originally joined to a
full-length figure that perhaps stood on a pedestal in a
public place.[3]

The Santa Barbara Bearded Head is that of a middle-
aged man; his hair is cut close and low on the forehead in the
Roman style, and he has a short, rather unruly beard and
joining moustache. His expression is somewhat grim —
tightly closed lips, with a downward turn, intensely staring
eyes — and he looks to be a strong-willed, perhaps stubborn,
Roman magistrate. The hair is rendered in long, clearly
defined strands that sweep forward from the back of the
head and almost fully conceal the brow. The ears are modeled
in a surprisingly cursory fashion, and the eyebrows, too,
are only lightly indicated with a series of short, carefully
incised diagonal lines at the very edge of the sharp browline.
All the emphasis is on the eyes themselves, deeply set and
carefully modeled. An inverted lunette and a short vertical
"highlight" ridge are used to indicate the pupils, and a
semicircular incision defines each iris. Both pupil and iris are
partly obscured by the upper eyelids, however.

Although the somewhat Classical appearance of the
Santa Barbara Bearded Head, particularly implied in the hair
and beard, calls to mind Roman sculpture of the period of
Hadrian (A.D. 117–138), which was strongly influenced by
Classical Greek art, it is more likely that the head dates
from the following century, perhaps from the reign of the
emperor Gallienus (A.D. 253–268), who was, like Hadrian,
an ardent philhellene.[4] The rendering of the eyes conforms
to portrait heads of the Severan and post-Severan periods,
and the wide cheekbones are markedly consistent with those
found in portrait heads usually assigned to the Gallienic
period.[5]

[1]C. Vermeule, *Greek and Roman Sculpture in America*
(Berkeley, 1981), no. 294, p. 342. Dated to the beginning of
the 3rd century A.D. and believed by Vermeule to be late
Antonine to Severan; see C. Vermeule, "The Late Antonine
and Severan Bronze Portraits from Southwest Asia
Minor," *Eikones* (Antike Kunst 12; Bern, 1980), pp. 186f.

[2]A number of large Roman bronze figures and fragments
were discovered at Kremma or its vicinity in western Turkey,
and some of these are now in American collections; see
C. Vermeule, *Roman Imperial Art in Greece and Asia* (Cam-
bridge, Mass., 1968), p. 548, additions to p. 401, no. 9.
The Santa Barbara head shows no signs of belonging to any
of the Kremma bronzes. See M. Del Chiaro, *Roman Art in
West Coast Collections* (Santa Barbara, 1973), no. 64.

[3]The pedestal could have been either freestanding or of the
bracket type which projected from columns or piers that
often lined the important avenues of many prosperous cities
of the Roman East such as Palmyra, Gerash, or Ephesos.

[4]B. Felletti Maj, *Museo Nazionale Romano*, I Ritratti (Rome,
1953), nos. 300, 301. See also J. Inan and E. Rosenbaum,
Roman and Early Byzantine Sculpture in Asia Minor
(London, 1966), nos. 179 and 180.

[5]Felletti Maj, no. 304; H. von Heintze, *Römische Porträt
Plastik aus Sieben Jahrhunderten* (Stuttgart, 1961); Inan and
Rosenbaum, nos. 126, 293; and B. Felletti Maj, *Iconografia
Romana Imperiale da Severo Alessandro a M. Aurelio Carino
222–285 d.C.* (Rome, 1958), pp. 220ff. and nos. 289–296.
See also A. Massner, "Porträt eines Atheners aus der Zeit des
Kaisers Gallienus," *Jahrbuch des Bernischen Historischen
Museums in Bern* 49 (1969–1970), pp. 305–319.

Bronze. Height 29 cm (approx. 11½ in.).
The head was thinly cast (about 3 mm). Some soldering is present on the inner surface along several breaks. Small pieces are missing along these lines on the outer surface at the sides and on the top of the head. A large portion is altogether lost at the back left side. Minor restoration was attempted at the nostril and bridge of the nose. A consistent dark green patina appears throughout, with traces of soil visible within the deep grooves and incisions. A serrated or saw-toothed edge at the base of the neck is remarkably well preserved except for slight damage at the front left side.

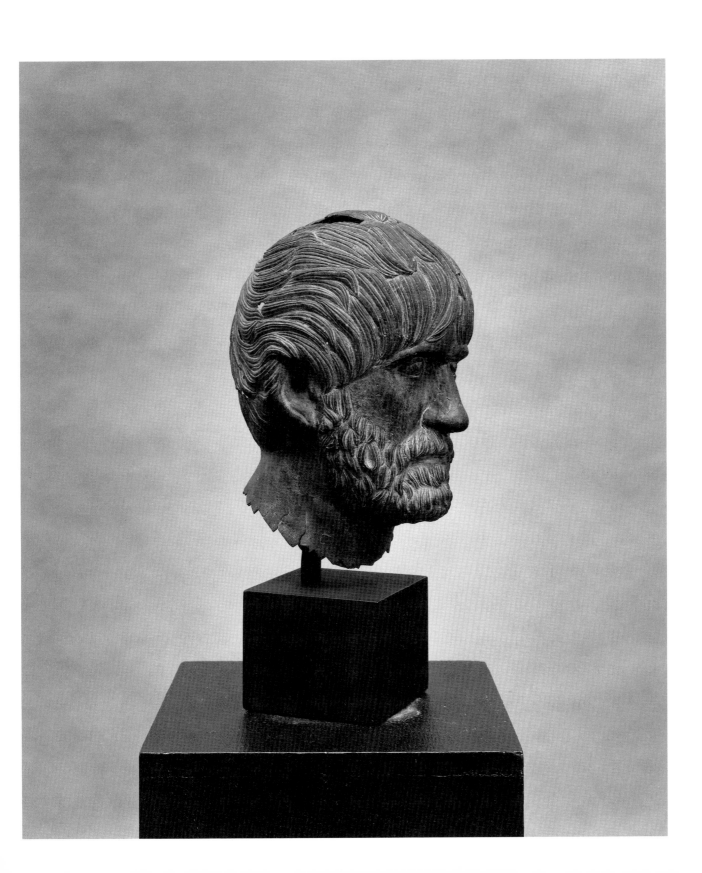

22.

Fragmentary Table Leg (Trapezophoron)

Roman. Possibly early 1st century A.D.

1955.27

Gift of Wright S. Ludington

FIG. 18.

62

This single, fragmentary leg is probably one of an original set of three matching legs that were designed to support a marble table top (cf. fig. 18). Within the repertory of Hellenistic and Roman tables, three-legged types seem to be more common than four-legged specimens, the legs being sometimes of marble, sometimes of bronze.[1] The Romans loved mixtures of rich and variegated marbles, and this taste was reflected in the design of pedestals for candelabra and so on and tables of decorative marbles of various colors and textures, often, like this leg, richly carved.[2] The mixture of vegetal-floral forms with human elements was common in furniture as well as in painting, fresco, and sculpture. One particularly interesting example in furniture is the head of Herakles, wearing his lion-skin cap, which is presently in the Vatican collection.[3]

The fine modeling of the head of Polykleitan type and the exposed left hand of the youth on the Santa Barbara Table Leg shows great sensitivity and skill, and it would appear to place the leg in the Augustan period (first century A.D.) rather than in one of the later classicizing periods.

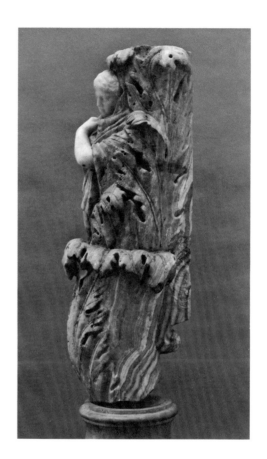

[1]M. Del Chiaro, *Roman Art in West Coast Collections* (Santa Barbara, 1973), p. 34, no. 46 bis., p. 84 and frontispiece (color). See G. Richter, *The Furniture of the Greeks, Etruscans, and Romans* (London, 1966), p. 110ff. See also C. Vermeule, "Bench and Table Supports: Roman Egypt and Beyond," *Studies in Ancient Egypt, the Aegean, and the Sudan* (Boston, 1981), pp. 180–192 which includes the Santa Barbara table leg (p. 188, no. 47, fig. 11a).

[2]T. Kraus, *Das Römische Weltreich, Propyläen Kunstgeschichte*, vol. 2 (Berlin, 1967), colored pl. XV, opp. pl. 264.

[3]G. Lippold, *Die Skulpturen des Vaticanishen Museum*, III, 2 (Berlin, 1956), pl. 85, no. 14. See also Richter, fig. 580, for an example in New York (Metropolitan Museum of Art, inv. no. 13.115.1). To judge by the description: a wreathed head; see A. H. Smith, *Catalogue of Sculpture in the British Museum*, III (London, 1904), p. 405, no. 2522. For a cloaked youth "emerging" from vegetal forms, see A. Giuliano, ed., *Museo Nazionale Romano, Le Sculture* I.1 (Rome, 1979), no. 16, p. 14, a herm, however, rather than table leg. A cloaked youth who offers a close parallel is, of course, the "Boy from Tralles": see R. Lullies and M. Hirmer, *Greek Sculpture* (New York, 1957), pls. 280–281; C. Havelock, *Hellenistic Art* (New York, 1979), pl. 131.

Marble; yellowish-brown variegated for the acanthus supporting portion, fine-grained white for the inserted head and arm of the youth. Preserved height of leg, 44.5 cm (17½ in.); height of youth's head, approx. 5.5 cm (2⅛ in.). Graceful vegetal form (acanthus) comprises the supporting element or leg. The inner side is straight and vertical, the outer side gracefully curved. The leg is broken at the top very near the terminal point of contact with the underside of the table top, where a rectangular flat area (4 by 8 cm) can be discerned. A left arm and detailed head carved in fine-grained white marble have been inserted into a *togatus* body that merges into the acanthus forms.

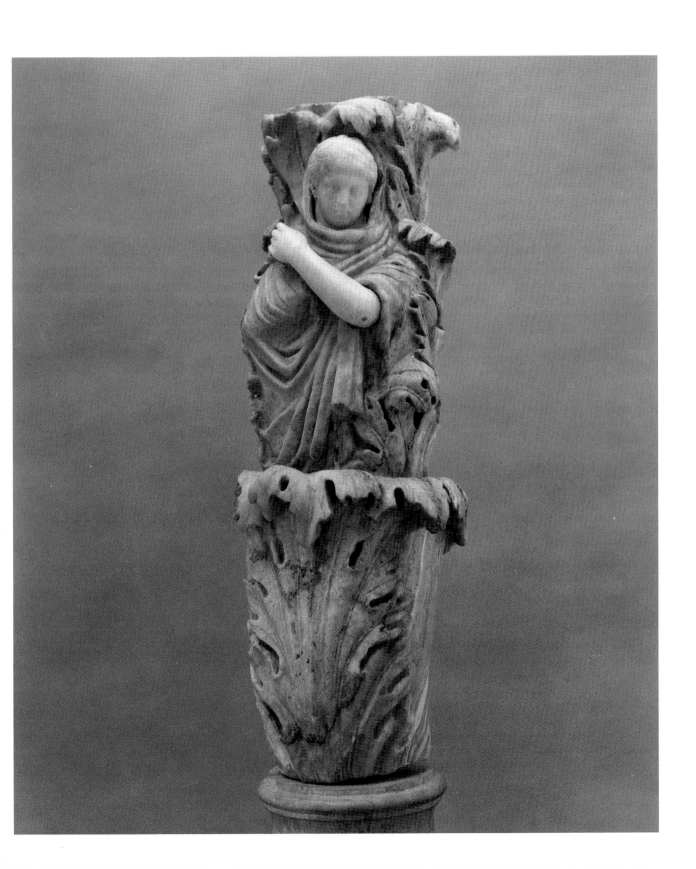

23.
Funerary Loutrophoros
Greek (Attic). Second half of the 4th century B.C.
1941.2.34
Gift of Wright S. Ludington

Although this monumental funerary loutrophoros is earlier in date than all but one of the sculptures in the Santa Barbara Museum of Art thus far presented, it is placed at the end of this section on sculpture because of its nonfigural character, unique in the collection. Loutrophoroi — tall vases having a high neck and flaring mouth — were used in Attica in the fourth century B.C. for the special purpose of bringing water from the sacred fountain of Kallirrhoe for the nuptial bath and for washing the body before burial.[1] Vases of this type could be either of bronze or of terracotta decorated appropriately, in red- or black-figured technique, with marriage or funerary scenes. Vases of the funerary type were also left on the graves of unmarried persons.[2]

It was from this last function that the type represented by the Santa Barbara loutrophoros evolved, probably as early as the beginning of the fourth century B.C. Some grave stelae of this period bear reliefs showing loutrophoroi.[3] The solid marble loutrophoroi, often monumental in size like the Santa Barbara example, had the specific function of marking graves.[4]

In the Santa Barbara loutrophoros, the ornate volute handles, obviously inappropriate to a terracotta piece,[5] as well as the intricate gadroons or fluting on the extant original body clearly imply that the vase imitated a loutrophoros of the bronze type. The exquisite double guilloche that encircles the body just below the handles, though suitable to marble, also suggests metalwork.[6]

Since the loutrophoros was a vase shape normally in use only in Attica, and certainly not elsewhere in the specific function of grave marker, there is every reason to believe that the Santa Barbara marble loutrophoros is an original work that was produced in Attica near the end of the fourth century B.C.

Although not actually products of classical art but examples of Early Christian sculpture that continued the classical "pagan" traditions,* the following pair of reliefs — originally details from a single monument, a marble sarcophagus — are best set apart from the sculptures thus far listed.

[1]G. Richter and M. Milne, *Shapes and Names of Athenian Vases* (New York, 1935), pp. 5f. See also J. Noble, *The Technique of Painted Attic Pottery* (New York, 1965), pp. 27f.

[2]Harpokration, a writer of the first century A.D., defines the loutrophoros as follows: "It was the custom at marriage to send for a bath on the wedding day; for this purpose they sent the boy who was the nearest relative and these boys brought the bath. And it was also the custom to put a loutrophoros on the tomb of those who died unwed." That a loutrophoros need not necessarily mark the grave of a woman is suggested by a passage in Pseudo-Demosthenes, XLIV.18: "Archiades died unmarried. And the proof? A loutrophoros stands on his tomb." For examples of both nuptial and funerary painted types, see Noble, fig. 169; E. Karydi, "Schwarzfigure Lutrophen im Kerameikos," *Mitteilungen des deutschen archäologischen Instituts, Athen,* pp. 90–103 and pls. 38–53; D. Kurtz and J. Boardman, *Greek Burial Customs* (Ithaca, 1971), pp. 149ff. and figs. 166–169.

[3]See H. Möbius, *Die Ornamente der Greichische Grabstelen* (Berlin, 1929), pls. 17b, 24b, and 30b; H. Diepolder, *Die Attischen Grabreliefs* (Berlin, 1931), pl. 1; *Bulletin of the Metropolitan Museum of Art* 16 (1957–1958), p. 191 right.

[4]See G. von Kokula, *Marmorlutrophoren* (Köln, 1974).

[5]The handles on terracotta loutrophoroi are understandably less elaborate in order to prevent breakage during use. More often than not, they are close to and nearly parallel — with a slight swell — to the long neck; frequently there is a bracing strutlike link between the body and the midpoint of the handle. See, e.g., Noble, fig. 169.

[6]For one in the National Museum, Athens, possibly from the same workshop, see M. Bieber, *The Sculpture of the Hellenistic Age* (New York, 1961), fig. 203.

Marble; white (Pentelic). Restored height, 2.4 m (approx. 6 ft. 8 in.).
The marble has a warm, light brown patina, which is emulated in the modern
(cement) portions. The upper part of the vase, from near the base of the long neck
and portions of the handles, is entirely modern. More than half of the footed
base is also restoration. The vase now stands on a modern cylindrical base of wood.

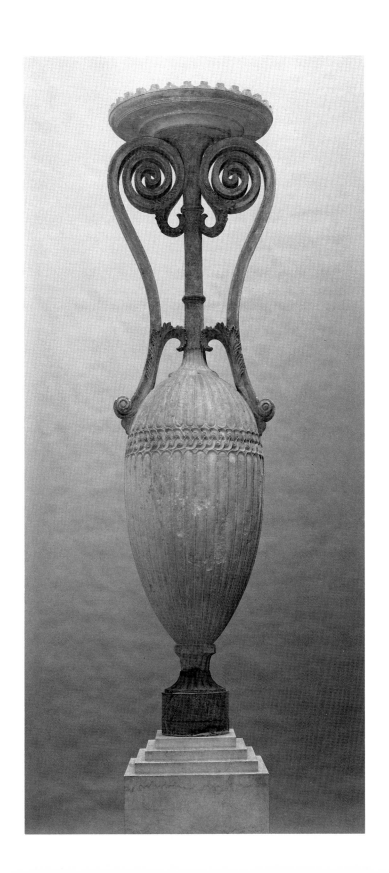

24 and 25.
Two Corner Masks (Heads of a Youth) from the Lid of an
Early Christian Sarcophagus
Last third of the 3rd century A.D.
00.194.1, 00.194.2
Gift of Wright S. Ludington

66

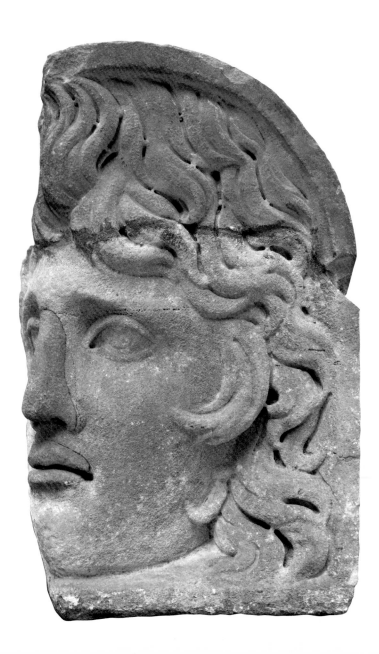

These two fine masks, unquestionably created as a pair and
as integral parts of a sarcophagus lid at its far ends or
frontal "corners" (see fig. 19), would normally be viewed in
strict profile rather than three-quarter view.[1] On the evi-
dence of style and type of mask, the sculptural workshop
responsible for sarcophagi that generally bear such corner
masks presents reliefs at the central portion of the lid which
frequently depict scenes from the Old Testament (Jonah
story)[2] and possibly the New Testament (Banquet) — (see
fig. 19). Assignment of the Santa Barbara masks to a specific
Early Christian sarcophagus workshop can be readily
appreciated by comparison of the shared youthful heads
(and their curved frames) with clearly similar details:[3]
straggly hair with upright strands above the forehead, for-
ward swirls at the neck, and a marked wavy tress at the
temple; wide-open eyes with deeply cut pupil placed close
up against the eyelid; a small mouth with full yet parted
lips; and a rounded but prominent and prowlike chin. On
the basis of such evidence, the Santa Barbara relief heads
must have originally decorated a sarcophagus lid produced in
an Early Christian workshop active during the late third
century A.D. — perhaps in the environs of Rome.

For the sake of convenience, the following seven sculp-
tures (nos. 26–32) presented here as an addendum are recent
gifts promised to the Santa Barbara Museum of Art
and are appropriate for inclusion in the present publication.
Of the seven promised gifts, four (nos. 26, 27, 28 and 30)
are those of Wright S. Ludington;* two (nos. 31 and 32), gifts
of Suzette Davidson; one (no. 29), a gift of Margaret
Mallory. All of these sculptures are handsome and impres-
sive examples of their kind, and will serve admirably to
strengthen and enhance the collection of classical antiquity
in the Santa Barbara Museum of Art. As with the sequence
observed in the main portion of the catalogue, the
sculptures presented in this addendum will be listed
according to their considered chronological order (i.e.,
possible prototypes, etc.).

*I am grateful to Mr. Wright Ludington, who again
demonstrated characteristic generosity and respect for
scholarly research by allowing students of yet another
of my seminars to visit his home in order to examine
sculptures in his collection. Three of these are included
in the addendum as promised gifts, and I am
indebted to two of my students for some of their
observations: Michael Brunner (no. 26) and Robin
Ptacek (nos. 27 and 30).

Marble; white, fine-grained. Average height, 51 cm (20 in.); average width, 32 cm (12½ in.); thickness, (00.194.1) 14.3 cm (5⅝ in.), (00.194.2) 11.2 cm (4⅜ in.).

The heads are obviously cut away from the ends of the lid with considerable care in order to preserve the curved border or "frame" that sets them off from the central portion of the lid. Nonetheless, a horizontal break may be seen above the brow of each mask.

FIG. 19.

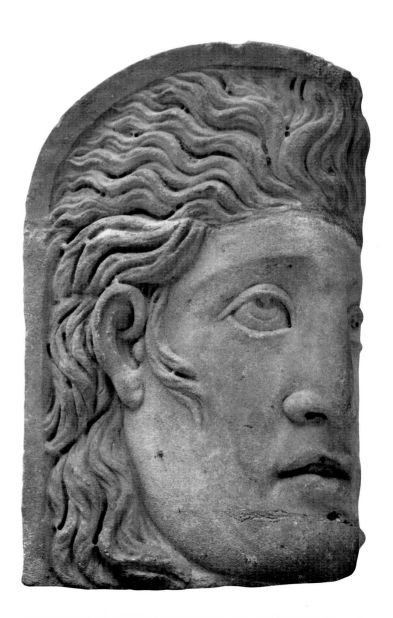

[1]The manner in which these masks turn the corner from front to side of the sarcophagus lid recalls the aesthetic turn devised by Greek architects for the capital ("angle capital") to some of their "corner" columns of the Ionic order; e.g., the North Porch of the Erechtheion on the Athenian Akropolis — see A. W. Lawrence, *Greek Architecture* (Baltimore, 1957), pl. 70; R. Scranton, *Greek Architecture* (New York, 1965), pl. 58; W. B. Dinsmoor, *The Architecture of Ancient Greece* (New York, 1975), pls. XLVI, XLVII, and XLIX.

[2]F. Gerke, *Die christlichen Sarkophage der vorkonstantinische Zeit* (Berlin, 1940), pp. 38–51.

[3] G. Wilpert, *I Sarcophagi Cristiani Antici* I (Rome, 1929), pl. X, 1 and pl. LIII; Gerke, pl. 23, 4; pl. 25, 2 and pl. 28, 3; F. Deichmann, G. Bovini, and H. Brandenburg, *Repertorium der christliche-antiken Sarcophage* (Wiesbaden, 1967), no. 778, pl. 124 and no. 793, pl. 127.

26.
Venus Genetrix
Roman adaptation of a late-5th-century B.C. Greek original
(by Kallimachos?)
Promised gift of Wright S. Ludington

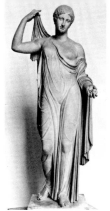

FIG. 20.

This handsome sculpture of a woman with left breast and left shoulder bared stands nearly three-quarter life-size and serves as an excellent example of the so-called Venus Genetrix type.[1] "Venus" rather than "Aphrodite" acknowledges her Roman rather than Greek appellation in view of its association with the patron goddess of Rome, whose cult statue for the Forum of Caesar was created in 46 B.C. — a commission by the Julian Clan of the sculptor Arkesilaos, who apparently selected a Greek fifth-century type as his source of inspiration.[2] The appellation "Venus Genetrix" derives from the inscription *VENUS GENETRICI* accompanying a representation of the statue type found on the reverse of Roman coins.[3] The Santa Barbara goddess may be assigned to the "Freijus Venus Genetrix" type — an erroneous designation since the statue is now believed to have come from the Naples region rather than the former Roman legionary colony at Freijus in southern France (see fig. 20).[4] The statue type enjoyed a special popularity among the elite women of Roman society from empress on down, some of whom chose the statue type for their own full-length portraits, but presented more demurely with heavier and less diaphanous drapery, and generally with both breasts covered.[5] The Santa Barbara Venus, however, does not exhibit this sense of Roman false modesty and may be numbered among the most sensitively rendered representations of the Venus Genetrix type.

Venus is here shown in full possession of all the grace and sensuousness normally associated with the Goddess of Love. She stands with her weight supported by the left leg, the right bent in counterbalance (contraposto) to her left arm down to the side, the right upraised to grasp one end of the chiton (sleeveless light linen garment) in order to adjust the portion that has slipped off the left shoulder (see fig. 20). The drapery clings in a transparent configuration that reveals the well-rounded body, while the rotundity of the exposed left breast is emphasized by the sweeping curves of the drapery directly below. As suggested by the Freijus Venus Genetrix and a terracotta figurine from Myrina of the "Tanagra" type,[6] the lowered and outstretched left hand of the Santa Barbara Venus may have held an apple — symbolic of the prize awarded to the goddess by Paris in his judgment of the celebrated beauty contest in which she competed against Hera (Juno) and Athena (Minerva).

Of the well-known late-fifth-century B.C. Greek sculptors equated with the creation of the inspirational prototype for the Venus Genetrix — Phidias, Alkamenes, Kallimachos, etc.[7] — Kallimachos may prove the best choice, on the evidence chiefly of the treatment and the pattern of the transparent drapery, which recalls the reliefs of the balustrade to the Temple of Athena Nike on the Athenian Akropolis with which his name has been associated.[8]

[1]C. Harcum, "A Statue of the Type Called the Venus Genetrix in the Royal Ontario Museum," *American Journal of Archaeology* 31 (1927), pp. 141–152; A. Fraser, "A New Venus Genetrix in Washington," *ibid.*, 39 (1935), pp. 454–457; G. Elderkin, "The Venus Genetrix of Arkesilaos," *Mitteilungen des deutschen archäologischen Instituts, Rom* 48 (1933), pp. 261–276; G. Richter, *Catalogue of the Greek Sculpture in the Metropolitan Museum of Art* (Cambridge, Mass., 1954), no. 57 and pl. XLIX; C. Vermeule and N. Neuerburg, *Catalogue of the Ancient Art in the J. Paul Getty Museum* (Malibu, 1973), no. 3; W. Peck, "A New Aphrodite in Detroit," *Bulletin, Detroit Institute of Arts* 54 (1976), pp. 125–131; cf. C. Vermeule, *Greek and Roman Sculpture in America* (Berkeley, 1981), no. 146, p. 179; and L. Bianchi "La Venere Genetrice di Claudio Saturno," *Archeologia Classica* 29 (1977), pp. 128–133. See also M. Bieber, *Ancient Copies* (New York, 1977), pp. 46f.; B. S. Ridgway, *Fifth Century Styles in Greek Sculpture* (Princeton, 1981), pp. 198ff.

[2]Pliny, *Natural History* 35.156. See also, O. Grossi, "The Forum of Julius Caesar and the Temple of Venus Genetrix," in *Memoirs of the American Academy in Rome* 13 (1936), pp. 215–220.

[3]See Bieber, pl. 26, figs. 144 and 145.

[4]The best preserved example of the Venus Genetrix type may be seen in the marble statue presently in the Musée du Louvre supposedly from Freijus (here fig. 20), which stands 4 ft. 10½ in. in height.

[5]Bieber, figs. 136, 139, 143, 146 and 149. See this Catalogue, no. 11 for analogous use of the Venus of Capua type for draped portraits of Roman empresses. The Venus Genetrix was also regarded as a patron goddess of marriage and, subsequently, revered by young unmarried women and widows.

Marble; white, fine-grained. Height, 1.24 m (approx. 4 ft.).
On this headless statue the upraised right arm is missing from near the shoulder;
the forearm is missing from the lowered left arm. The entire lower part of the
figure is lost from just below the ankles. Edges of the drapery are chipped away
at scattered points.

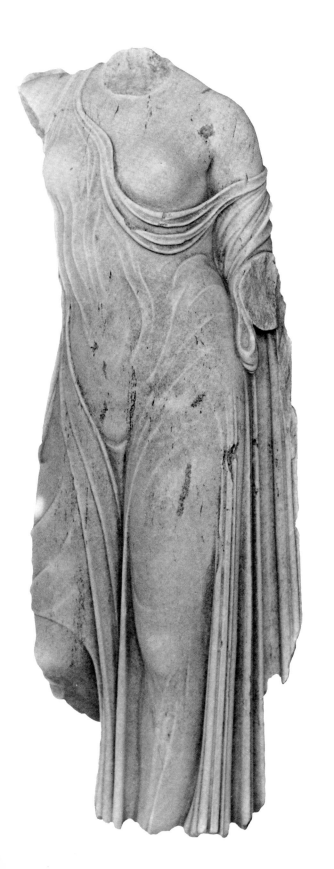

[6]R. Higgins, *Greek Terracotta Figurines* (London, 1967),
pl. 54, B.

[7]S. Reinach, *Recueil des têtes antiques* (Paris, 1903), p. 92;
A. Fürtwangler, *Masterpieces of Greek Sculpture* (Chicago,
1914), p. 76; R. Carpenter, *The Sculpture of the Nike Parapet*
(Cambridge, Mass., 1921), p. 61; P. Garner, *New Chapters
in Greek Art* (Oxford, 1926), p. 40; G. Richter, *The Sculpture
and Sculptors of the Greeks* (New Haven, 1957), p. 239;
J. Charbonneaux, *La sculpture grecque classique* (Paris,
1945), p. 49. See in particular, G. Gullini, "Kallimachos,"
Archeologia Classica 5 (1953), pp. 133–162 and S. Karusu,
"Neues zur Aphrodite Frejus ein attischen Kopf und das
Fragment einer Grabstele," *Mitteilungen des deutschen
archäologischen Instituts, Athen* 89 (1974), pp. 151–172.

[8]See Carpenter; also R. Lullies and M. Hirmer, *Greek
Sculpture* (New York, 1977), pls. 187–189.

27.

The Lansdowne Hermes
Roman copy (Hadrianic?) of a Greek original dating to the
4th century B.C. (by Lysippos?)
Promised gift of Wright S. Ludington

This major, over life-size statue enjoyed notoriety when once in the Lansdowne collection, England,[1] a collection equally celebrated for a Herakles that has also found its way into another southern California collection.[2] Assuming a contraposto pose characteristic for Classical statues of youths, the handsome young Hermes stands with his weight supported by the right leg, the left bent and the greater portion of its foot correctly restored with heel upraised. The modern right forearm and hand are placed akimbo with the hand placed back against the buttock.[3] The left arm, which hangs down to the side, supports a heavy mantle — the only clothing for the nude god — draped over the forearm. One end of the mantle trails behind and up to rest over the left shoulder, the opposing end hanging vertically in bunches to just below the left knee. A remnant of a rod discernible in the much-damaged left hand must have belonged to a missing *caduceus* (a staff with two entwined snakes symbolic of a herald) — the identifying attribute of the messenger-god, Hermes.[4]

Although numerous fifth- and fourth-century statues of nude youths (gods and athletes) assume the contraposto stance, the closest parallels in type and pose to the Lansdowne Hermes are offered by the Hermes Andros and the Hermes Belvedere ("Antinous") in the Vatican — the latter, like the Lansdowne Hermes, utilizing a palm stump as the statuary support.[5] Attributed to Pheidias and not to be discounted altogether in favor of a Lysippic prototype, is a nude youth known to us as the "Hermes Ludovisi," a statue that possesses small wings sprouting from the head of the god but, more significantly, displays the same contraposto pose and configuration of drapery as the Lansdowne counterpart.[6] Of all the parallels cited in an attempt to attribute the Lansdowne Hermes to a specific Greek sculptor, the most convincing example is offered by the Hermes Andros — not solely for its pose and drapery, but for the general character and tilt of the head with its pointed chin, and for the detailing of the hair, that is, the curly tufts and the distinctive pattern of the locks at mid-forehead.

Since the stylistic association between the Lansdowne and Belvedere Hermes seems to be highly credible, and since the latter statue is reported to have been unearthed at Hadrian's Villa near Tivoli not far distant from Rome, there is every good reason to also accept the Lansdowne Hermes as a Roman copy dating to the Hadrianic period (between 117 and 138 A.D)

[1]See J. Dallaway, *Statuary and Sculpture among the Ancients* (London, 1816), p. 341; G. Waagen, *Treasures of Art in Great Britain* (London, 1854), p. 149; and *Christies Sales Catalogue 1930*, p. 154.

[2]For the "Lansdowne Herakles" in the J. Paul Getty Museum, Malibu, California (inv. no. 70 AA.109), see S. Howard, *The Lansdowne Herakles* (Malibu, 1966 and 1978); see also C. Vermeule, *Greek and Roman Sculpture in America* (Berkeley, 1981), no. 54, p. 84. Interestingly, another former Lansdowne sculpture is presently on extended loan to the J. Paul Getty Museum from the Los Angeles County Museum of Art, namely, the "Lansdowne Athlete."

[3]An unfinished Hermes in the H. Clifford Smith collection, London, provides the sole example of the Hermes Andros type that may preserve the proper aspect of the right hand, i.e., resting flat against the right hip; see J. Chittenden and C. Seltman, *Greek Art* (London, 1946), fig. 148.

[4]The "Farnese Hermes" in the British Museum cradles a caduceus and wears winged sandals: see G. Hafner, *Geschichte der Griechische Kunst* (Zurich, 1961), p. 284, fig. 288.

[5]For the "Hermes Andros," see S. Meletzis and H. Papadakis, *National Museum of Archaeology, Athens* (Munich, 1966), no. 44, p. 45. For the "Hermes Belvedere," see H. Brummer, *Statue Court of the Vatican Belvedere* (Stockholm, 1970), p. 210, fig. 197. Additional but more fragmentary parallels are known: see G. Richter, *Three Critical Periods in Greek Sculpture* (Oxford, 1951), fig. 88; *Catalogue of the Greek Sculpture in the Metropolitan Museum of Art* (Cambridge, Mass., 1954), pl. LXXXV, no. 105.

[6]W. Fuchs, *Die Skulptur der Griechen* (Munich, 1969), p. 81, fig. 81.

Marble; white; fine-grained (Parian?). Height, 1.98 m (7 ft. 1 in.); height of circular plinth, 18 cm (approx. 7 in.).
The head has not been broken away from the body. The right arm below the elbow including the right hand, the right leg from mid-thigh to ankle, the left foot, tip of nose, and nostrils are all modern. Breakages are mended at the upper right arm, left elbow, left knee, and calf. The original left hand is without its thumb, index, and middle fingers. A stump of a palm tree serves as the statue-support.

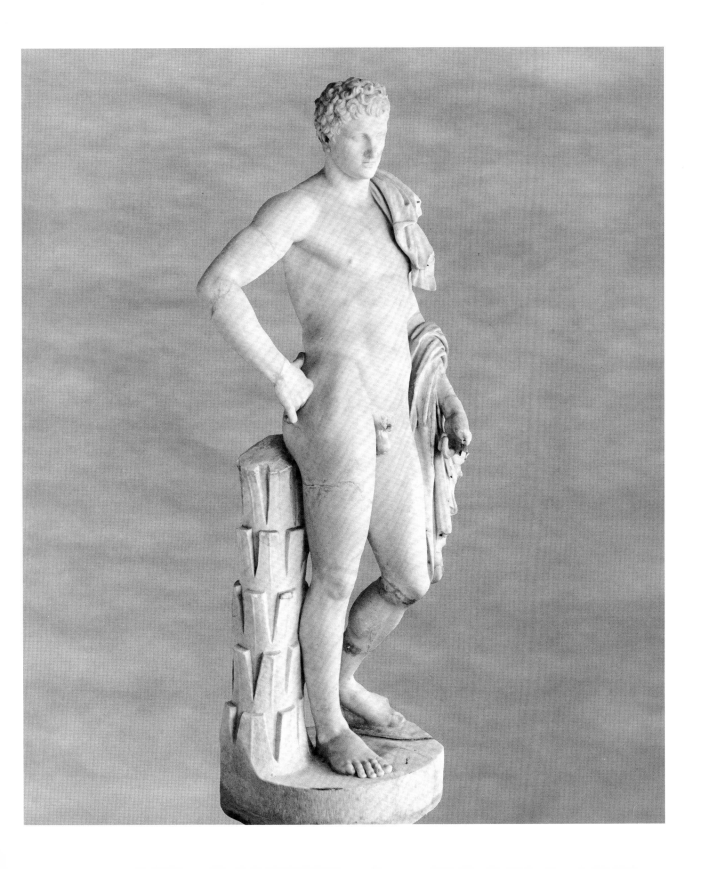

28.
Aphrodite (Venus)[1]
Roman version of the 2nd century B.C. of a Greek prototype dating
to the end of the 4th century B.C.
Promised gift of Wright S. Ludington

The statue type represented by this large-scale sculpture is that of the Aphrodite of Syracuse (the Aphrodite Landolini)[2] — itself a Roman copy executed in the second century B.C. and ultimately derived from the Aphrodite of Kos by Praxiteles.[3] Numerous copies or versions inspired by that celebrated statue very likely originated in the Aegean islands surrounding Kos or on the nearby mainland of Asia Minor (Turkey).[4]

In keeping with the popularity of sensual deities during the Hellenistic age, Aphrodite as the Goddess of Love was a subject prolific in sculpture — particularly statuary, and many examples were inspired by either the semi-nude Aphrodite of Kos or her more famous counterpart, the Aphrodite of Knidos also by Praxiteles.[5] Both of these statues show the goddess surprised while bathing, and, although both originals are lost, their character, pose, and style have survived to a degree in the countless copies and versions that have come down to us.

This particular Aphrodite in Santa Barbara has two especially close parallels — each with the left arm wholly intact but the right arm preserved only down to just above the elbow — that are presently in Karlsruhe and Syracuse, Italy (the Aphrodite Landolini).[6] At her upper right arm, the Ludington Aphrodite wears an armlet — a decorative feature shared with some of her counterparts, but in some cases worn on the right rather than the left arm.[7] The head of the goddess for the Santa Barbara statue is somewhat vapid and manneristic yet recalls the head type usually associated with the Medici Venus (Aphrodite of Knidos type), which, in sharp contrast to the Santa Barbara head, is far more delicate. These heads share in common an elaborate topknot and a broad fillet clearly visible at the back and sides but obscured above the forehead by strands of wavy hair.

This popular Aphrodite type has served as the basis for another statue type, better known as a "nymph" who, although draped in a similar manner, holds a conch shell at arm's length before her at the waist — a statue that would have served admirably as a garden or fountain decoration.[8]

[1]The Ludington Aphrodite was published by Bieber when the statue was yet on the New York market: see M. Bieber, *Ancient Copies* (New York, 1977), figs. 236–237 and n. 44 to chap. 6 (p. 69).

[2]See A. Giuliano, "La Afrodite Callipige di Siracusa," *Archeologia Classica* 5 (1953), pp. 210-214.

[3]See G. Richter, *The Sculpture and Sculptors of the Greeks* (New Haven, 1970), fig. 685; Bieber, figs. 216–218 (cf. Aphrodite of Arles).

[4]B. Felletti Maj, "Afrodite pudica — Saggi d'arte ellenistica," *Archeologia Classica* 3 (1951), pp. 33-65, with extensive bibliography.

[5]Felletti Maj, pp. 61f.; Richter, figs. 668–670; Bieber, fig. 228. See also C. Alexander, "The Statue of Aphrodite," *The Metropolitan Museum of Art Bulletin* (May 1953), pp. 241-251.

[6]For the Landolini Aphrodite (Aphrodite of Syracuse), see note 2, above.

[7]With the armlet on the left arm, see Richter, figs. 668 and 670; Bieber, figs. 216–219. At the right arm, see Bieber, fig. 228.

[8]A. Giuliano, ed., *Museo Nazionale Romano, Le Sculture* 1. 2 (Rome, 1981), no. 3 (inv. no. 31), pp. 186ff., in which L. de Lachenal interestingly suggests that the shell may allude to the *birth* of Aphrodite. See also Bieber, fig. 238.

Marble; white, fine-grained. Height, 188 cm (approx. 74 in.).
The head is broken away but reattached at the neck; the right hand is damaged
and its fingers are missing. The left arm is missing from near the elbow on down,
but its hand is preserved and holds the drapery. Additional minor breakages
and mending are evident throughout. The plinth is rectangular.

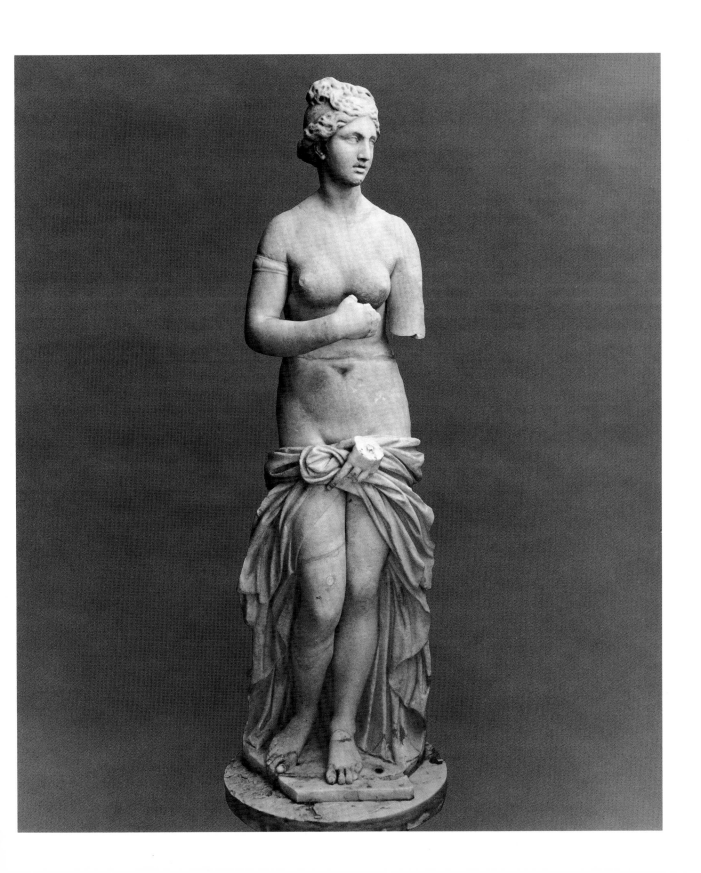

29.
Nude Torso of a Youth (Apollo?)
Roman or early-3rd-century copy after a prototype of the
early 3rd century B.C.
Promised gift of Margaret Mallory

74

Because this lithe and graceful torso has much in common
with the torso listed in the main portion of the catalogue
(no. 7), much of what has been said for the former is
applicable to this handsome but fragmentary statue. To judge
by the extant portions of the deltoids, the now missing
arms were not raised but positioned downward and
outward — the right straight to the side, the left slightly
outward. Hence, owing to the absence of attributes (lyre or
the like) that may have been held in hand or supported
by the arms, identification of this torso — or torso no. 7 —
as other than that of a youth, must remain highly con-
jectural. The remnants of long tresses at each shoulder,
however, would serve equally well to suggest Apollo or a
youthful Dionysos.

Although similar in type to the torso no. 7, the marked
S-curve of the body is in the opposing direction, and closer
analysis discloses a less slim body with a more fleshy and
less tight musculature — best seen in the pectorals — which
permits more conspicuous nuances in the modeling of
the surface. An especially strong Praxitelean flavor pervades
both torsos, whose prototypes, consequently, may date
to the late fourth or early third century B.C.

Marble; white, fine-grained. Preserved height, approx. 48 cm (approx. 19 in.). The head and the arms are missing, as are the legs from about mid-thigh down. Portions of the genitalia have been broken away. The buttocks are restored by extensive patching. Pitting and abrasions occur at scattered points — especially at the stomach and upper left abdominal area.

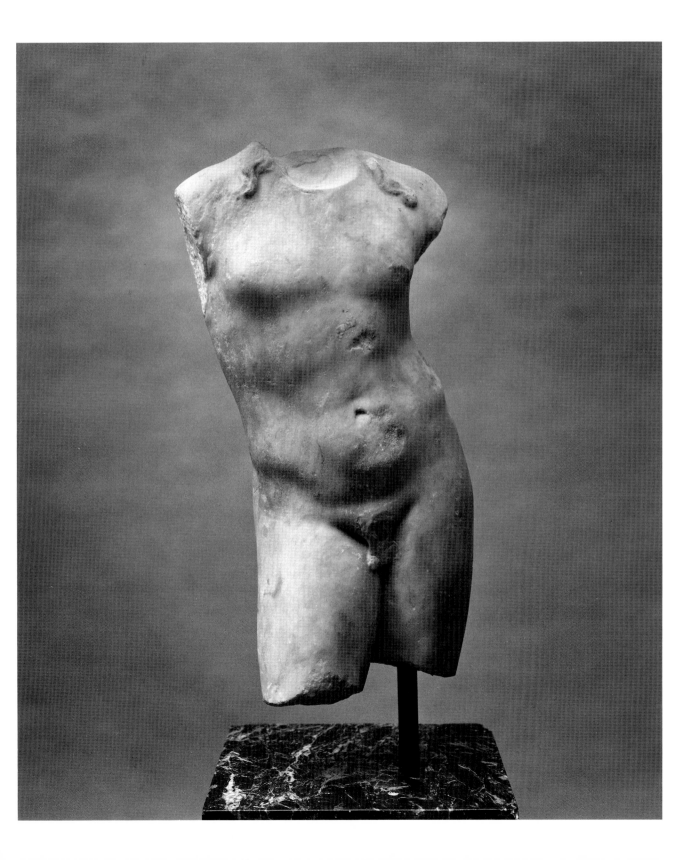

Statue Group. Achilles and Troilos
Hellenistic original. 2nd century B.C. Probably from Asia Minor.
Promised gift of Wright S. Ludington

This active and relatively small figured group is comprised of two male figures and a diminutive horse — the standing figure detached, the horse and rider in one piece. The entire group was doubtlessly set on a single plinth (base), and, consequently, the standing figure would have been placed higher and closer to the mounted figure than now. Although the rider appears to be dismounting with his body turned toward the standing figure, he is actually being pulled off the horse by his hair, which was originally grasped in the left hand of his adversary. Evidence for such reconstruction is offered in a stereotyped pose already well known by the late fourth century B.C. — especially in scenes depicting the struggle between the Greeks and the Amazons (women warriors).[1] The theme of rider dragged off his or her horse became a popular one in Greek as well as Etruscan art.[2]

The rider in the Santa Barbara group, naked but for vestiges of a mantle clasped around his neck and shoulders,[3] grips the reins tightly with his left hand as he is unceremoniously pulled from his mount. Despite the fact that the head of the rider is altogether missing, one can sense the violent backward twist of the head. Although it is difficult to ascertain what, if anything, was originally held in the now missing right hand of the rider,[4] the corresponding hand for the standing figure must have unquestionably held the sword drawn from the now empty scabbard that rests high at his left side, suspended from a broad strap that runs diagonally across back and chest and over the right shoulder. The strap itself is decorated with a narrow strip along each side and a series of circular, disklike forms set about 5 cm apart.

The undersized horse,[5] displaying a double-cropped mane and tousled forelocks, is "blanketed" with a double lion-skin, the heads of which meet mouth to mouth at the horse's chest. The legs and paws of the lion-skin dangle at the horse's hind and shoulder quarters. Beneath the belly of the horse, a tree trunk serves as a support for both horse and rider, whose disproportionately large left foot rests flat against the lion-skin at the left flank of his mount.

That this lively group does not refer to an Amazonomachy (battle of the Greeks and Amazons)[6] is quite obvious from the sex of the two figures. If the rider, who seems to be attacked as he is about to dismount, can be regarded as Troilos, and the aggressor as the Greek hero Achilles, then the sculptural figured group represents the popular Homeric tale of the ambush and death of Troilos.[7] According to prophecy, beseiged Troy would never fall as long as the youngest son of the Trojan king Priam survived. Because of this we can better understand why such a heinous mismatch as that of the Greek warrior Achilles against the youthful Troilos was acceptable to the ancient Greeks.

On the evidence of the horse type (long neck, small head with its prominent eyes set into a clearly articulated bony structure, small upright ears, flat cheeks, gaping mouth and distended nostrils, and double-cropped mane with contrasting forelocks) and its lion-skin covering,[8] and the appearance of both Achilles and Troilos as nude figures, Asia Minor more than elsewhere in the Hellenistic world is likely its area of origin. During the second and first centuries B.C., such small sculptures — perhaps conceived

[1]A. Yayali, *Der Fries des Artemisions von Magnesia am Mäander* (Tübingen, 1976), pl. 26, 1 and pl. 32, 3; also A. Davesne, *La frise du Temple d'Artémis a Magnésie du Méandre: Catalogue des fragments du Museé du Louvre* (Paris, 1982), figs. 8, 9, 31, 34, 65 and 69. For the "hair-pulling" pose, see B. Ridgway, *Fifth Century Styles in Greek Sculpture* (Princeton, 1981), p. 21 and note 14.

[2]I. Krauskopf, *Die Thebanische Sagen* (Mainz, 1974), pl. 15, 1 and 2; F. H. Pairault, *Recherches sur quelques séries d'urnes de Volterra a représentations mythologiques* (Rome, 1972), see pls. 48–65.

[3]Because the back of the rider is so carefully carved and the musculature well modulated, the mantle must have extended

backwards off the body in a billowing configuration.

[4]I do not believe the mounted figure carried a sword in his right hand, to judge by the absence of a scabbard (cf. the standing figure). However, traces of matrix at the horse's hindquarters, on its flesh, and on the lion-skin, indicate that some object (a weapon?) rested at this point. If Troilos, could it have been from the hydria he bore to the fountain? However, I know of no precedent for this in sculpture, but as an "attribute" in vase painting (although normally shown overturned, at times broken, hence of terracotta rather than bronze) it would normally appear beneath the horse: see *American Journal of Archaeology* 68 (1964), pl. 31, fig. 1.

as table-top decorations or as small garden pieces to be viewed in the round[9] — would have appealed to cultured patrons or buyers. Interestingly, the Asiatic horse type in this Achilles-Troilos group finds its closest parallels in monuments created in Asia Minor, for example, the celebrated Alexander Sarcophagus now in Istanbul[10] or the fragmentary colossal horse from the Mausoleum at Halikarnassos.[11]

In view of the typology of the horses, the parallels in stereotyped pose, and the chronological association as early as the second half of the fourth century B.C., I believe that the Santa Barbara Achilles-Troilos Group was produced for an educated, upper-class client by an Asia Minor sculptural workshop during the second century B.C., strongly influenced by earlier, late-fourth-century models.

[5]The curious difference in scale between the horse and the human figure is not uncommon in Greek art (cf. the Parthenon frieze) and may in part be explained by the desire to economize on expensive marble but, more likely, to place greater emphasis on the more important human figure than on the horse. See G. Richter, *Animals in Greek Sculpture* (Oxford, 1930), p. 15.

[6]See D. von Bothmer, *Amazons in Greek Art* (Oxford, 1957).

[7]For another Achilles and Troilos sculptured group, see Pairault, pl. 66,a.

[8]Richter, pp. 14–18, 44; R. Markman, *The Horse in Greek Art* (New York, 1969). See also *Catalogue. The Frederick M.*

Watkins Collection (Cambridge, Mass., 1973), p. 84, no. 36.

[9]See A. Giuliano, ed., *Museo Nazionale Romano, Le Sculture* I. 1 (Rome, 1979), no. 111, p. 163; J. Hartmann, *Antike Motive bei Thorvaldsen* (Tübingen, 1979), pl. 37, 1.

[10]See R. Lullies and M. Hirmer, *Greek Sculpture* (New York, 1957), pls. 232–239; Markman, fig. 58; and C. Havelock, *Hellenistic Art* (New York, 1979), pls. 150–152.

[11]Richter, fig. 77; Markman, fig. 55.

Marble; translucent white, fine-grained; extensive root-marks. Maximum preserved height of horse and rider, 50 cm (approx. 19¾ in.); length of horse, 38 cm (approx. 15 in.); preserved height of standing figure, 32 cm (approx. 12½ in.).

Fragmentary. Missing portions: heads of both figures; right hand and right foot from above the ankle of rider; right and left forearms of standing figure, as well as his left leg and portion of the right from knee down; the left hind leg, left foreleg, and greater portion of the right foreleg of the horse. The left leg of the rider was once broken away but was rejoined, as was the right upper arm of the standing figure. Some abrasions and slight chipping are present throughout (e.g., muzzle and ears of the horse).

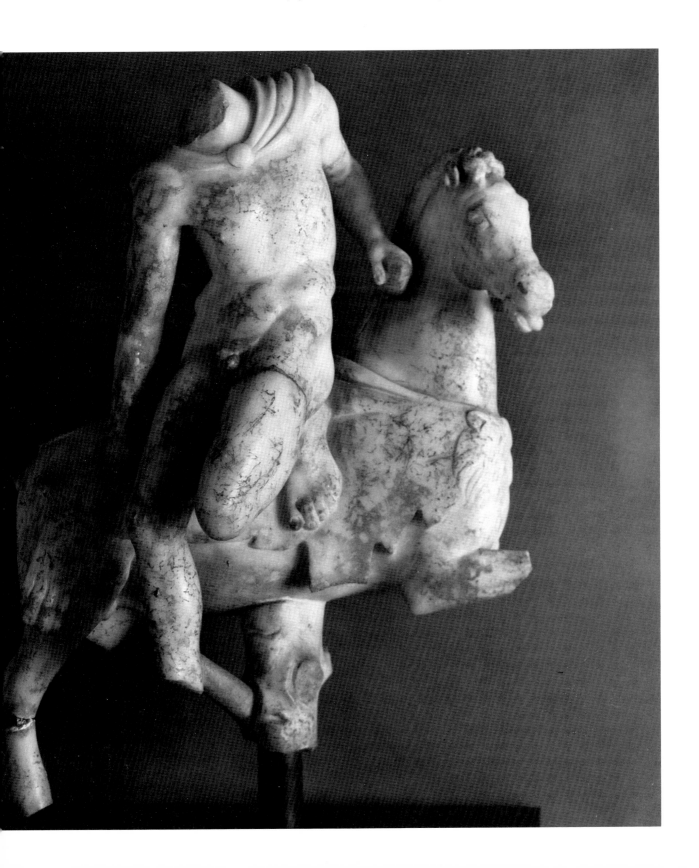

31.
Mithras Sacrificing a Bull
Roman. Second half of the 2nd century A.D.
Promised gift of Suzette M. Davidson

This statue group must be placed among the finest of Roman representations of the Mithraic tauroctony (the god Mithras sacrificing a bull).[1] Basically a Near Eastern religion, the cult of Mithras became especially popular among the Roman military and mercantile classes, consequently spreading rapidly throughout the Roman Empire — from Hadrian's Wall in Britain to the banks of the Euphrates.[2] As a God of Light and Protector of Mankind, Mithras appealed strongly to Roman legionnaires, who regarded themselves as the protectors of the people. Consequently, the army was in large part responsible for the rapid spread of Mithraism, which may explain the presence of Mithraic "temples" at far-flung corners of the Roman Empire during the third and fourth centuries A.D. Coming to the fore toward the end of the second century A.D. and thriving for nearly three centuries, this austere cult, with its secret initiation rites and promised salvation, engendered a strong emotional appeal that posed a serious challenge to Christianity — another Near Eastern mystery "cult" that accounts largely for Mithraism's demise.[3]

According to Indo-Iranian sources (cf. the Avesta, or sacred Persian text), Mithras was regarded as a God of Light, created by Ahura Mazda from a rock or stone to partake in an everlasting struggle against the Lord of Darkness. Roman worshippers, exclusively male since women were excluded from participation in any of the rituals, engaged in a cult not wholly unlike others of its time in their concepts of ritual death, purification, and ultimate rebirth — all demanding preparatory ceremonies, hymns, and chants, not to mention the sworn oath never to reveal cult secrets.[4] The performance of Mithraic ritual would normally take place in an underground environment or at least in some place shut off from natural light (for example, a cave or its simulation), preferably with or near a source of water, and the dark or dimly lighted "temples" or sanctuaries with their stony, cavelike interiors doubtlessly recalled the actual birth of Mithras.

The countless representations of the Mithraic tauroctony in Roman paintings and sculpture, in relief or in the round, are strongly stereotyped in pose and details, and normally depict a youthful Mithras at the hindquarters of the bull — believed to be the first living creature created — which the god forces to the rocky ground by grasping its nostrils, ears, or area below its muzzle as he twists its head violently back and thrusts his sword into the beast's right shoulder.[5] At the moment of sacrifice, ears of corn or grain supposedly sprouted from the animal's tail and, at times, from its wound. Creatures normally associated with this sacrificial scene are a snake and a dog, each drinking the blood that flows from the wound, symbolic of plentiful Nature and its nourishment. In addition, a scorpion is represented biting or grasping the bull's genitals. Such a consistent theme, or iconography, has been interpreted as essentially a fertility theme, as suggested by the sprouting corn and the implied nourishment received by the snake and dog. The scorpion is never represented with its tail raised as if to sting but, on the contrary, relaxed, and it may therefore have more an astrological significance than one of fertility — denoting the opposites, Scorpio and Taurus.[6]

In the Santa Barbara sculpture, the missing tail of the bull must have originally looped upward with its end resting on the left haunch, where traces of the resting surface are clearly visible.[7] To judge by the preserved position of Mithras' neck, particularly the location of his throat, the position of the god's head was not twisted around, but looking downward at his sword hand. The left leg of Mithras is bent back, the right leg straight to the back with foot on the rocky ground.

[1]A. Oikonomides, *Mithraic Art* (Chicago, 1975). See also F. Cumont, "L'art dans les monuments Mithraiques," *Revue Archéologique* 3 (1899), pp. 193–202 and *The Mysteries of Mithras* (Chicago, 1903); see also A. Schütze, *Mithras — Mysterien und Urchristenturm* (Stuttgart, 1972).

[2]C. Daniels, "The Role of the Roman Army in the Spread and Practice of Mithraism," *Mithraic Studies* 2 (1975), pp. 249–274. See also J. Toynbee, "Still More about Mithras," *The Hibbert Journal* 54 (1963), pp. 319–326.

[3]S. Brandon, "Mithraism and Its Challenge to Christianity," *The Hibbert Journal* 53 (1955), pp. 105–114.

[4]M. Vernasseren, *Mithras, The Secret God* (London, 1963).

[5]For an especially close parallel in the Cincinnati Art Museum (inv. no. 1968.112), see C. Vermeule, *Greek and Roman Sculpture in America* (Berkeley, 1981), no. 198, p. 237.

[6]J. Hinnels, "Reflections on the Bull Slaying Scene," *Mithraic Studies* 2 (1975), p. 300.

[7]See Schütze, fig. 86.

Marble; gray dense and extremely fine-grained. Maximum preserved height, approx. 49 cm (19½ in.); maximum length, 84 cm (approx. 33 in.).
But for the missing head, the sculpture is remarkably well preserved. A major portion of bull's tail is missing. There is some chipping to the bull's throat area and trailing edges of Mithras' mantle. Slight abrasions are evident at the right thigh and left knee of Mithras and right cheek of bull.

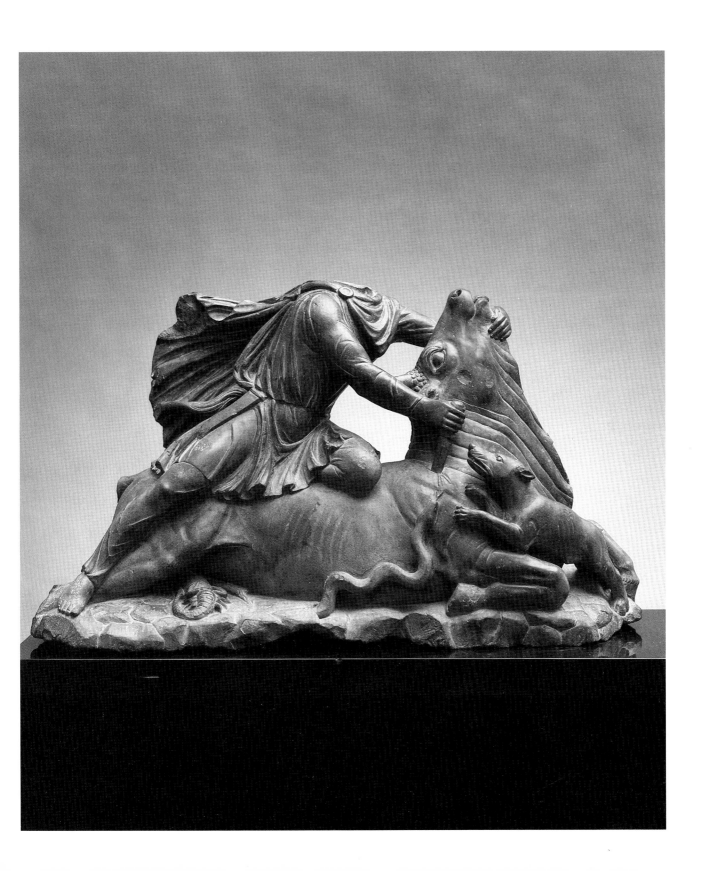

32.
Head of Alexander
Roman (Severan). First half of the 3rd century A.D.
Promised gift of Suzette M. Davidson

This fine head, albeit highly idealized, has been identified
as a portrait of Alexander the Great,[1] which to judge by its
keen sense of modeling and superb bronze casting, was a
worthy tribute to the much revered Macedonian leader who
extended Greek culture as far east as the borderlands of
India and present-day Afghanistan (ancient *Gandhara*). The
head can be assigned to the Roman period, most likely
created in Asia Minor, as proposed by Ariel Herrmann,
primarily on the evidence of the rendering of the eyes —
solid with pupils incised rather than inlaid, a technique
known for bronze statues of Severan rulers discovered at
Kaisereion, Turkey.[2] It should be noted that the eyes for the
bronze head of the bearded man presented earlier in this
catalogue (no. 21) were also cast along with the head,
but their technique of detailing — a deep concavity or pit for
the pupil — differs markedly.

 A testimonial to the admiration that Alexander
managed to instill throughout the classical world is con-
vincingly provided by the countless "portraits" of him
produced in the Hellenistic world and the Roman Empire
long after his death (ca. 323 B.C.). The Santa Barbara Head of
Alexander dates to Severan times, but more specifically, to
the reigns of Caracalla and/or Alexander Severus (between
A.D. 211 and 235). As observed by Ariel Herrmann,
several marble rather than bronze heads of Alexander —
an example in Dresden and another in Vienna — offer close
stylistic parallels.[3]

[1]*The Search for Alexander. Supplements to the Catalogue,*
Chicago, 1981, no. S-4, and San Francisco, 1982, no. S-3.
Entry S-4 by Ariel Herrmann.

[2]See note 1. Cr. C. P. Jones, *Mitteilungen des deutschen
archäologischen Instituts, Athen* (1977–1978), pp. 267ff.;
C. Vermeule, "The Late Antonine and Severan Bronze
Portraits from Southwest Asia Minor," *Eikones* (Antike
Kunst 12; Bern, 1980), pp. 186ff.

[3]See note 1, above.

Bronze. Height, 30.5 cm (12 in.).
The head was reassembled from numerous fragments. Most of the top, the left
side, and a goodly portion to the back of the head are missing.

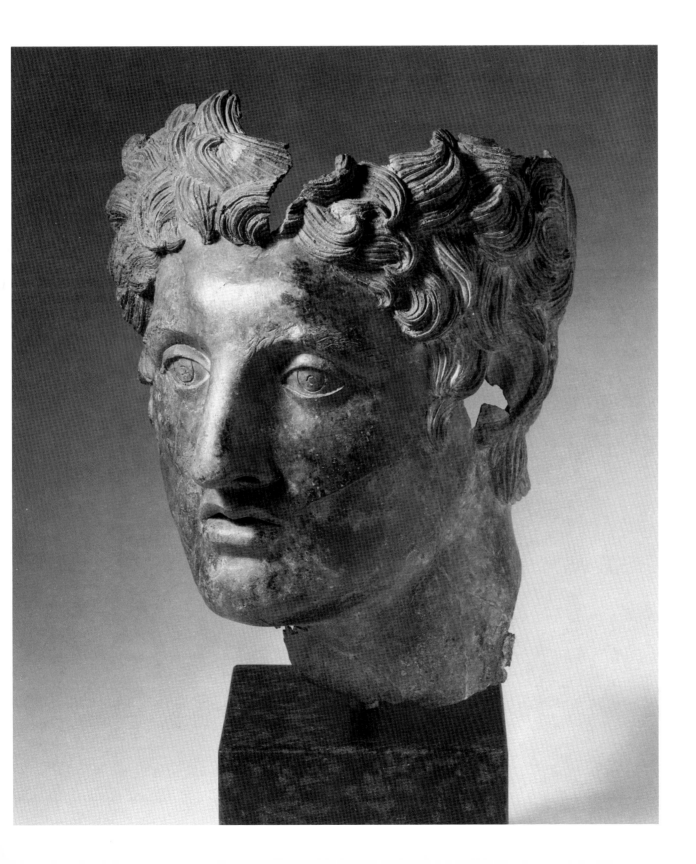

33.
Torso of Herakles
Roman statuette based on a Greek type of the late 3rd-early 2nd
century B.C.
1951.26.1
Gift of Mrs. Burton G. Tremaine

This exceptionally fine and sensitively carved statuette must represent a Herakles type, to judge by the preserved portion of a knotty club[1] — one of the major attributes of the hero-god — originally cradled in an upright position in his left arm.[2] However, since a Herakles type with *cornucopia* (horn of plenty) is known in Classical sculpture,[3] it may be possible that the cradled "club" is actually a cornucopia. In such a case, its location would be similar to the now preserved segment of the club, and would also possess the downward taper. If, however, the Santa Barbara torso does represent Herakles with cornucopia rather than club — although I favor the latter type — it marks a relatively rare instance of the god with lion-skin over one shoulder and not, as is more common, with lion-skin draped across both shoulders and tied about the neck by its paws, the mask worn cap-like on his head.[4]

The Santa Barbara torso originally showed Herakles in a frontal pose with the weight of his body primarily borne by the right leg, the left placed forward, as is strongly suggested by the noticeable overlap of the inner left thigh just below the scrotum. The only trace of drapery is found at the left shoulder, front and back, by reason of the subtly modeled undulations running diagonally across the vertical folds — especially clear at the thicker forward edge — this assuredly indicates a pelt, namely, a lion-skin, another attribute of Herakles. The lost portion of the lion-skin for the Santa Barbara torso fell vertically to his left side and once touched the upper left thigh, where there is yet preserved a vertical line of matrix.

The now missing left arm — very likely draped with the lion-skin — supported Herakles' club, whereas the lost right arm must have been held outward away from the body, a position indicated by the limited traces of the deltoid muscle at the upper fracture of the shoulder. As has been pointed out for the large Torso of Herakles (no. 9), the broad breakages at the neck, defined on this torso by a slightly raised edge, mark the presence of a full beard, another attribute of the god.

Quite strikingly, the general stance of the Santa Barbara statuette — including the coincidental portions of the breakage at the legs — recalls the torso of a "Hellenistic Ruler" in Berlin.[5] Although the Berlin statue (not statuette) discloses slightly heavier muscular definition, the two sculptures share enough in common to suggest a production dating to the last quarter of the third or the beginning of the second century B.C. In view of the eclectic character of much Hellenistic sculpture, I believe that the slender and graceful nature of this small torso stands closer to Praxitelean than Lysippic prototypes.

[1]"Knotty" club: see our fig. 7; G.M.A. Richter, *The Sculpture and Sculptors of the Greeks* (New Haven, 1970), figs. 43, 754, 807, and 808; Bieber, *The Sculpture of the Hellenistic Age* (New York, 1961), figs. 79, 81, and 84. For the celebrated bust of the Roman emperor Commodus as Hercules, see R. Brilliant, *Roman Art* (London, 1974), p. 178.

[2]"Upright" in view of the conspicuous downward taper to the extant portion of the club.

[3]See P. Hartwig, *Herakles mit dem Fullhorn* (Leipzig, no date).

[4]Cf. G. Becatti, "Una statua di Ercole con cornucopia," *Bollettino d'Arte* 53 (1968), pp. 1–11; in particular, figs. 6, 7, 12 and 14.

[5]W. Reinecke, *Einführung in die griechische Plastik an der Hand von Meisterwerken in Alten Museum* (Berlin, 1931), pp. 97f., fig. 73; and Bieber, fig. 429. For several other torsos close in pose and style, see A. Giuliano, ed, *Museo Nazionale Romano, Le Sculture* I, 2 (Rome, 1981), p. 291, no. 12; and Bieber, fig. 299.

Marble; white, fine-grained. Preserved height, 31 cm (approx. 12¼ in.).
The head, neck, left and right arms, most of the left leg, and the right leg from
mid-thigh are missing. There are large holes above the scrotum and at the neck
area for attachment of the missing parts (penis and head). The fine white marble
shows abundant root-marks at the front and back, and the surface has mellowed
to an overall yellowish-gray tone.

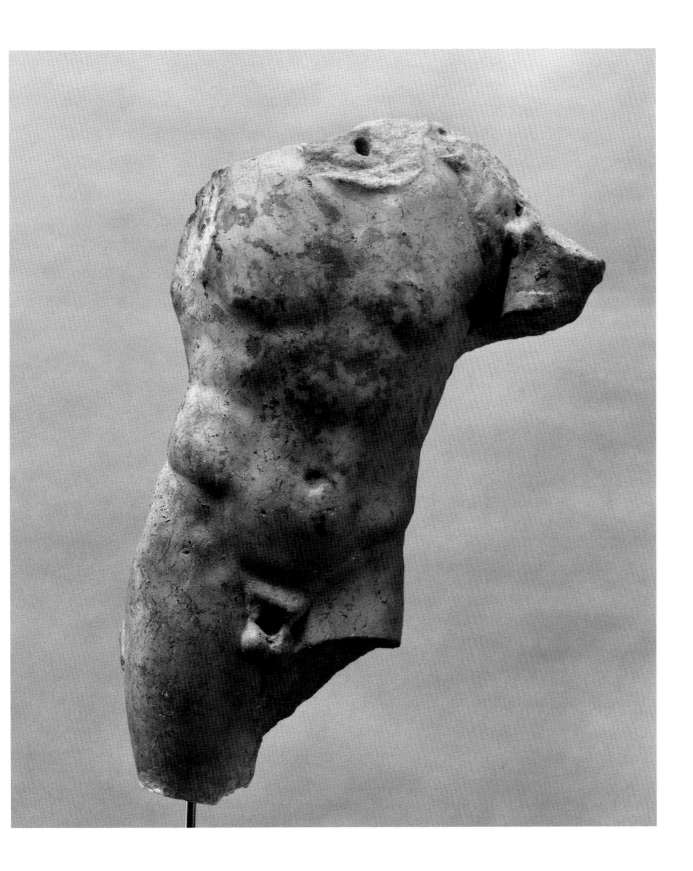

Sculpture in a Classical Landscape

In the early summer of 1961, American archaeologists working on the Greek island of Kea found the ruins of a temple that had been continually in use, with only brief interruptions, from at least the fifteenth century B.C. to the Graeco-Roman period.[1] This was unusual enough, but shortly afterward they made a discovery that must rank, if not among the most spectacular, at least among the most intriguing in the history of Aegean archaeology.

From one of the upper levels of the temple ruins, dating to the eighth century B.C., emerged a life-size clay head, sitting on a terracotta base and surrounded by a ring of stones (fig. 22). The Keans had apparently found the piece by chance: it belonged to one of a number of statues dedicated in the temple around 1500 B.C. (cf. fig. 23), presumably as a votive offering, but buried by a catastrophic earthquake shortly thereafter. Now, still in the same temple but over six hundred years later, it became itself an object of worship.

Ancient Greek culture was a culture of images. True, some early Greek rites developed around aniconic objects and abstract shapes such as the pyramid and column that stood for Zeus and Artemis in Sikyon, or the log, fallen from heaven and then plated with bronze, called Dionysos Kadmos in Thebes.[2] Yet while these were indeed still revered even in Roman times, it was the actual physical forms of the gods themselves that were the most popular and most widespread objects of worship. The gods of Homer, whose *Iliad* and *Odyssey* were probably composed at about the same time that the Keans discovered and began to venerate their ancient idol, were not pillars and triangles but living, breathing beings, immortal but of human form. Naturally then, it was in this guise that the Greeks, for the most part, preferred to worship them.

Of course, it is idle to ask when and where Greek sculpture of this kind actually "began," especially since all

FIG. 22.

FIG. 23.

[1]J. L. Caskey, "Excavations in Keos," *Hesperia* 31 (1962), pp. 278–281; 33 (1964), pp. 326–331; also R. Eisner, "The Temple at Ayia Irini: Mythology and Archaeology," *Greek, Roman and Byzantine Studies* 13 (1972), pp. 123–134.

[2]Pausanias, *Description of Greece* ii.9.6, ix.12.4; on such cults see A. D. Nock, *Essays on Religion and the Ancient World* (ed. Zeph Stewart; Cambridge, 1972), pp. 860–864.

[3]On religious continuity during the Dark Age see especially R. V. Nicholls, "Greek Votive Statuettes and Religious

the primitive statues catalogued by Pausanias and others are now lost. Scattered finds of terracottas show that image-centered religious ritual endured in many locations throughout the centuries of isolation and poverty that followed the collapse of the Bronze Age civilizations in the twelfth century B.C.; chance discoveries like that made by the Keans, together with increasing contacts from the ninth century onward with image-using cultures of the Near East can only have served to stimulate the practice further. Homer's description of a Trojan offering to a life-size image of Athena offers a vivid picture of how elaborate was the homage that could be paid to such statues, actually possessed as they were by the spirits of the gods themselves.[3] At any rate, it shows that by around 750 the Greeks were certainly familiar with large-size cult statues in fully human form:

> When they had come to Athena's temple on the peak
> of the citadel,
> Theano of the fair cheeks opened the door for them,
> daughter
> Of Kisseus and wife of Antenor, breaker of horses,
> She whom the Trojans had established to be Athena's
> priestess.
> And Theano of the fair cheeks taking up the robe laid it
> Along the knees of Athena the lovely-haired, and praying
> She supplicated the daughter of powerful Zeus: "O lady,
> Athena our city's defender, shining among goddesses,
> Break the spear of Diomedes, and grant that the man be
> Hurled on his face in front of the Skaian gates; so may we
> Instantly sacrifice within your shrine twelve heifers,
> Yearlings, never broken, if only you will have pity
> On the town of Troy, and the Trojan wives, and their
> innocent children."
> She spoke in prayer, but Pallas Athena turned her head
> from her.
>
> *Iliad* vi. 297–311 (tr. Lattimore)

Athena was the patron goddess not only of Troy but of many Greek cities as well, and particularly of Athens, her special favorite. There she was worshiped through an ancient olive-wood image, itself fallen from the sky back in the long-forgotten past, in the northern sanctuary of the Akropolis (fig. 24). Every year on her birthday, Athenians of all classes marched in solemn procession to honor her, like her Trojan counterpart, with a new robe specially woven by girls chosen from the city's leading families. It is this event that is probably represented in the frieze of the Parthenon (fig. 25), the great marble temple built between 447 and 432 to house a new statue of her, the Athena Parthenos by Pheidias (fig. 26).[4]

To those used to wood, marble, or bronze, and to a more-or-less human scale, the Parthenos must have been a stunning sight indeed. She stood almost forty feet high, resplendent in full armor that, like her clothing, was completely plated with gold. Her feet, arms, and face were veneered with ivory, while individual details were picked out with exotic minerals and precious stones. Her sandals, shield, and helmet were emblazoned with mythological sagas proclaiming her power, while her right hand extended a winged Victory toward the awed spectator. Seeing her in all her glory, any Athenian who knew the traditions of his native land would at once have recalled the ringing words of the great lawgiver Solon, who around 590 had written:

> Our city, by the immortal gods' intent
> And Zeus' decree, shall never come to harm;
> For our bold champion, of proud descent,
> Pallas Athena shields us with her arm.
>
> Solon iv. 1–4 (tr. Gibert Highet)

Pheidias' vision of Athena, novel and compelling, was an immediate success and was to inspire centuries of imitations in all kinds of media and at every scale from the miniature to the super-colossal. The Santa Barbara Museum is lucky to own a Roman replica of one such version, the so-called Ince Athena type (no. 4; cf. fig. 2),

Continuity, c. 1200–700 B.C.," *Auckland Classical Essays Presented to E. M. Blaiklock* (Auckland and Oxford, 1970), pp. 1–38; B. C. Dietrich, *The Origins of Greek Religion* (Berlin and New York, 1974), pp. 191–289; W. Burkert, *Griechische Religion* (Stuttgart, 1977), pp. 88–98, 148–154; see also the careful and somewhat conservative summary by J. N. Coldstream, *Geometric Greece* (London, 1977), pp. 317–340. On the reawakening of Greece to Eastern stimuli, see especially J. Boardman, *The Greeks Overseas* (2nd ed.; London, 1980). On early Greek cult

images see H. -V. Herrmann, "Zum Problem der Entstehung der griechischen Grossplastik," *Archäologischer Anzeiger* (1974), pp. 636–638 (discussion of early wooden images in light of Homer passage quoted below); J. Papadopoulos, *Xoana e Sphyrelata* (Rome, 1980); I. B. Romano, *Early Greek Cult Images* (diss., U. of Pennsylvania, 1981); and, in general, B. S. Ridgway, *The Archaic Style in Greek Sculpture* (Princeton, 1977), chap. 2.

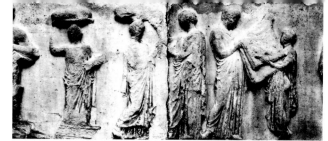

FIG. 25.

88

19X41

FIG. 24.

probably created within a generation of the completion of the Parthenos. Reduced to life-size once more, the goddess is now less remote, more human, more approachable; yet whether the ensuing gain in intimacy adequately compensates for the inevitable loss of majesty is something that each must judge for himself.[5]

In all likelihood, the Ince Athena was not itself a cult statue. More probably, it belonged to the much larger class of dedicatory or votive sculpture. Such offerings were simply gifts to the divinity in question, presented either to thank the gods for good fortune, or quite brazenly to solicit it (fig. 27). The practice was known in Greece from time immemorial; the clay statues from the Kean temple were apparently votives, and a thousand years later, the original of the Ince Athena, like the originals of the Apollo Kitharista (no. 10; fig. 5) aand the Peplophoros (no. 3), could well have served as their latter-day successors. Yet while the Apollo, for all its ebullience, remains a work about which it is difficult to be more precise than this, the Peplophoros was surely a Classical successor to the *kore*-votives of the Archaic period (fig. 28), holding out an offering of fruit or flowers to the titular divinity of the sanctuary, a mute and eternal reminder of the piety of the donor.[6]

The Doryphoros (no. 5; fig. 3) is another matter. Curiously for a work so renowned in antiquity, we know neither the location of the original nor its function; even its true identity remains uncertain. Contemporary reproductions of it from Polykleitos' home town of Argos could indicate that it stood there, perhaps in a sanctuary; a note in Pliny's encyclopedia (published in A.D. 77) telling us that "nude youths with spears, called images of Achilles" (34.18) were considered suitable for Roman gymnasia, suggests that this may have been its real subject.[7]

If this is so, then Polykleitos' boldness in transforming the mightiest and most extreme of the Greek heroes into a

[4]On the cults of the Akropolis and their significance, see especially C. J. Herington, *Athena Parthenos and Athena Polias* (Manchester, 1955) — though I do not believe in a cult of Athena Parthenos as such, distinct from that of the city goddess, Athena Polias. On the olive-wood image see J. H. Kroll, "The Ancient Image of Athena Polias," *Studies in Athenian Architecture, Sculpture and Topography* presented to Homer A. Thompson (*Hesperia* supplement 20, 1982), pp. 65–76; on the Panathenaia, see E. Simon, *Festivals of Attica* (Madison, 1983), pp. 55–72 — though I do

paradigm of measured humanity, an eptiome of the Classical ideal itself, must have raised some eyebrows at the time. His success, however, can be gauged by the way in which later sculptors of heroes and other men of might followed his precepts "like a law" (Pliny, *Natural History* 34.55). This much is clear from the other nude males in the Museum's collection, like the youth (no. 7), the Lansdowne Hermes (no. 27), and even the Farnese-type Herakles (no. 9) — though in the last case the Polykleitan paradigm has been twice recast, first by the innovating sculptor Lysippos of Sikyon (active ca. 370–310 B.C.), then by a Hellenistic follower of his working in the so-called baroque style. Indeed, it has even been argued that the brooding, pensive "Ares Ludovisi" (no. 6; fig. 4) is itself really an Achilles.[8] If so, its sculptor took a completely different tack from Polykleitos, exploring once again the extremes of the hero's character — in this case his enormous ego, cut to the quick by Agamemnon's appropriation of his slave-girl, Briseis.

Hero statues could be dedicated to the gods as votives, or could mark the tombs of the heroes themselves. Heroes, too, were venerated and given sacrifice, though as exemplars for lesser mortals to look up to and to follow — a function that is manifest in the Doryphoros itself, which served not only as a paradigm for artists but for generals, kings, and emperors as well, who were careful to have their own statues cast in its image.[9] Funerary sculpture as such is represented in the Santa Barbara collection by the marble loutrophoros (no. 23), and it is also just possible that the original of the Lansdowne Hermes (no. 27) was a grave statue. An earlier type of Hermes Chthonios ("Hermes of the Dead") may have stood above the mass grave of the Athenians killed in a great battle with the Spartans at Tanagra in 457;[10] one may fantasize that this later one may have served a similar function. Here, the Athenians' vain

FIG. 26.

FIG. 27.

not believe in her double procession; and for the Parthenon, F. Brommer, *The Sculptures of the Parthenon* (London, 1979).

[5]On late fifth- and fourth-century religious needs see especially W. K. C. Guthrie, *The Greeks and Their Gods* (London, 1950), chap. 12; E. R. Dodds, *The Greeks and the Irrational* (Berkeley-Los Angeles, 1951), chaps. 6–8; and for their impact on religious art, A. F. Stewart, "Dionysos at Delphi: The Pediments of the Sixth Temple of Apollo and Religious Reform in the Age of Alexander," in *Macedonia and Greece in Late Classical and Early Hellenistic Times* (National Gallery of Art, Washington: Studies in the History of Art 10 [1981]), pp. 205–228.

[6]For the Archaic korai, see G. M. A. Richter, *Korai* (London, 1968); C. A. Schneider, *Zur sozialen Bedeutung der archaischen Korenstatuen* (Hamburg, 1975); on votives in general, see Burkert, pp. 154–157.

struggles for freedom against the Macedonians at Chaironeia (338) and Lamia (322) come to mind, though nothing can be proved.

The establishment of Macedonian hegemony over Greece, and the phenomenal expansion of Greek horizons that followed the conquest of the East by Alexander the Great (336–323 B.C.: no. 23) not only created fresh markets for sculpture in the newly founded Greek cities of Asia, Syria, and Egypt, but also helped to broaden the uses to which the art was put.

Thus, it is almost impossible to decide whether the rash of Aphrodites from the Hellenistic world (cf. nos. 12–15), all more or less dependent upon Praxiteles' cult statue of Aphrodite for the eastern Aegean town of Knidos, were themselves cult statues, votives, or even decorative sculpture produced for palaces, wealthy private homes, or city parks. The Hellenistic recension of the "Herakles Farnese" type, here copied in no. 9 (cf. fig. 7), could easily have stood in a park, sacred or secular. If this were the case, the apples held by the hero behind his back would have immediately suggested a comparison with the Garden of the Hesperides, whence Herakles obtained them.[11] Likewise, the Satyr and Nymph (no. 16) may have served as a centerpiece for some bower or grotto in a garden, or could equally have been a dedication to Dionysos; the two are not, in the period, mutually exclusive, and the sculpture itself gives no clue.

Sometimes the uses to which sculpture could be put were bizarre indeed. The great riverboat of Ptolemy IV Philopator of Egypt (reigned, 221–205 B.C.) was lavishly equipped with banquet halls in gilded wood and exotic stones. One was embellished with cypress-wood colonnades and a golden entablature with carved figures of ivory attached, while nearby was "a rotunda-like shrine of Aphrodite with a marble statue of the goddess" (Athenaeus, *Deipnosophistai* v. 205d-e). A slightly earlier cruise ship

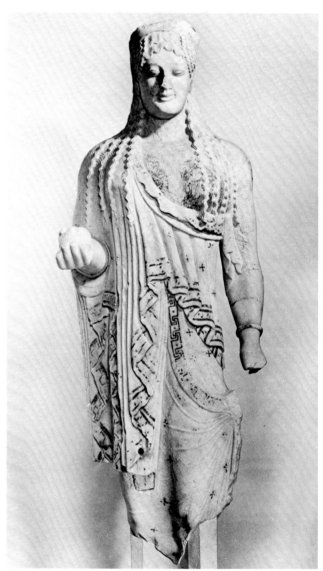

FIG. 28.

[7]For a more complete conspectus of the evidence for this identification, see A. F. Stewart, *Skopas in Malibu* (Los Angeles, 1982), p. 83, n. 8.

[8]S. Lattimore, "Ares and the Heads of Heroes," *American Journal of Archaeology* 83 (1979), pp. 71–78.

[9]See, e.g., M. Robertson, *A History of Greek Art* (Cambridge, 1975), pls. 163c (Roman general, Terme Museum), 190d (merchant from Delos, Athens National Museum);

FIG. 29.

built for Hieron II of Syracuse (reigned, 265–215 B.C.) even featured a Dionysiac paradise garden of vines and ivy, sheltering promenades that led to "a shrine of Aphrodite large enough to hold three couches, with a floor made of agate and as many other beautiful stones as are found in Sicily. It had walls and ceiling of cypress-wood, and doors of ivory and fragrant cedar, and was lavishly furnished with paintings, statues and drinking-vessels of all kinds" (Athenaeus v. 207e).

The reaction against such gross trivializing, even profanation, of the Olympian religion is manifested in the archaistic head (no. 17; cf. fig. 14). By resurrecting the numinous forms of a bygone age of "true" piety (see no. 1 and fig. 28), sculptor and client attempt to restore authority to a faith gone cold.

From around 200 B.C. the Hellenistic world, weakened by its endless wars, gradually began to disintegrate. Sucked in by Greek quarrels, a new people — the Romans — found themselves masters of the Mediterranean. Still largely peasant farmers at heart, they tended to despise what they saw as effete and ineffectual "Greeklings" with their passion for beauty and uncontrollable tongues. Yet simultaneously they envied them too, for their wealth, their culture, and their refinement. As the great Hellenistic centers fell one by one like overripe plums into their Roman conquerers' laps, they mercilessly plundered statues and paintings to decorate the temples and piazzas of the new world capital, while the more sensitive among them began to emulate Greek ways, hire Greek tutors, collect Greek books, and last but not least to possess themselves of Greek works of art.[12]

Such activities were frowned upon by conservatives, used to sterner things and brought up to know only one truly artistic tradition: portraiture. The urge to erect portraits, whether to commemorate ancestors or (later) as propaganda for the political leaders of the republic, was innate in

the Roman consciousness, which revered the past, valued the concrete and down-to-earth, and laid great stress upon individual physical action and achievement, in city politics as in war — provided that the greater good of the state was the goal, and that benefits accrued to it as a result.

So while "captive Greece took her savage victor captive" (Horace, *Epistles* ii.1.156), it was portraiture, both commemorative and honorific, that endured, lasting as long as Rome herself. Indeed, something of the trenchancy of late Republican portraits even resurfaces over three centuries later, in the Santa Barbara bronze head (no. 21).

To a people such as this, the tidal wave of riches from the East came as a double shock, profoundly affecting living standards and attitudes alike. Conservatives were in no doubt as to the results:

> It was conquered Asia which first sent luxury to Italy since L. Scipio brought over 1400 lbs. of engraved silverware and gold vases weighing 1500 lbs. for his triumphal procession in the 565th year from the foundation of Rome [189 B.C.]. . . . The victory over Achaia also gave immense impetus to the overthrow of our morals, for this victory, occurring . . . in the 608th year of the city [146 B.C.], introduced captured statues and paintings into Rome. And lest anything be lacking, luxury was nurtured at the same time by the fall of Carthage [also 146 B.C.] so that, as if by connivance of the Fates, there was now both freedom to enjoy vices, and permission to do so.
>
> Pliny, *Natural History* 32.148–150

By the later second century B.C., Roman aristocrats, waxing rich on the spoils of the East, were building themselves luxurious villas on the coast south of Rome, especially in the vicinity of the Bay of Naples, around the fashionable spas of Pompeii and Herculaneum (cf. fig. 29).[13] There they could retire in summer to enjoy a vacation from the cares of the city, some to read Greek and to write their own brands of philosophy, history, or poetry in emulation,

D. Strong, *Roman Art* (Harmondsworth, 1980), figs. 9 (Roman general from Tivoli, Terme Museum), 39 (Augustus from Primaporta, Vatican), etc.

[10]Suggested by S. Karouzou, "Hermes Psychopompos," *Deutsches Archäologisches Institut, Athenische Abteilung: Mitteilungen* 76 (1961), pp. 91–106.

[11]I owe this suggestion to B. S. Ridgway, "Greek Antecedents of Garden Sculpture," *Ancient Roman Gardens*

(*Seventh Dumbarton Oaks Colloquium on the History of Landscape Architecture;* Harvard, 1981), pp. 25–26.

[12]On Greek art and Rome, see J. J. Pollitt, *The Art of Rome: Sources and Documents* (Englewood Cliffs, 1965), pp. 29–90; M. Pape, *Griechische Kunstwerke aus Kriegsbeute und ihrer öffentlichen Aufstellung in Rom* (Hamburg, 1975); Strong, pp. 36–44, 58–63.

[13]See J. d'Arms, *Romans in the Bay of Naples* (Cambridge, 1970).

FIG. 30.

some to walk and collect seashells, fossils, and other nick-
nacks, others simply to sleep and eat. Naturally, there
was competition to adorn such villas with the best that Greek
art could offer, both painting and sculpture. And if originals
were not at hand, copies would have to do.[14]

Thus, in the 60s, we find Cicero (who owned several
villas in the Naples area) writing to his friend and agent
T. Pomponius Atticus in Athens, asking for statues and
reliefs to adorn his "Academy" garden:

> Anything which you have in any category which seems to
> you worthy of the "Academy" will do; don't hesitate to
> send it, and have confidence in my bank account. This sort
> of thing is my voluptuous pleasure. I'm looking for
> things that are most "educational"; Lentulus promises me
> his ships. Please see to this project diligently.
>
> Cicero, *Letters to Atticus* i.9.2 (67 B.C.)

And a little later the same year:

> I'm really pleased about what you wrote me concerning
> the *Hermathena*. This is exactly the sort of decoration that
> is appropriate for my "Academy", since Hermes is
> characteristic of all educational establishments, and Athena
> in particular (as goddess of Wisdom) is a distinguishing
> mark of mine.
>
> *Letters to Atticus* i.10.3

Vanity apart, the keynote throughout is suitability
of subject — for obvious reasons, one would not want a satyr
and nymph like no. 16 in an academy. Such distractions as
it furnished would better suit an ornamental pool in a
vine garden or a banquet hall. Indeed, much of the Santa
Barbara sculpture, being not Greek originals but Roman
copies of them, must once have adorned villas such as
Cicero's. The Lansdowne Hermes (no. 27) and the Ince
Athena (no. 4) would probably have suited him perfectly, as
would have the prim and proper nymph relief (no. 8).
Indeed, this last piece was but one of a series made in Athens
specifically for the upper-class Roman market: while it was

[14]On Roman collecting in general, see the two essays by
F. Preisshofen, "Kunsttheorie und Kunstbetrachtung," and
P. Zanker, "Zur Funktion und Bedeutung griechischer
Sculptur in der Romerzeit," *Le classicisme à Rome* (Fonda-
tion Hardt, Entretiens 24; Geneva, 1978) pp. 263–282,
283–314; also C. C. Vermeule, *Greek Sculpture and Roman
Taste* (Michigan, 1977).

bought by some rich customer in Roman Tunisia, three other examples have turned up in Italy, and two more have been found aboard the wreck of a ship which sank right at the start of its voyage, in Piraeus harbor around A.D. 120.

Cicero's attitudes toward art were typical of the Roman elite as a whole, though his tastes were perhaps more bookish and pacific than most; in another letter he upbraids a friend for buying a Mars (cf. no. 6 and fig. 4), for "what good is such a statue to me, the author of peace?" (*Letters to his friends* vii.23.2). For similar reasons he would have been equally uninterested in the Doryphoros (no. 5; fig. 3), even though this was generally popular in Roman educational establishments, since its physique was "just right both for war and for athletics" (Quintilian, *Institutio Oratoria* v.12.21; cf. Pliny, *Natural History* 34.18).

Clearly, in a world such as this, where sculpture served purely practical purposes, there was no such thing as "art for art's sake": uses ranged from the creation of "atmosphere" to such mundane employment as supports for lamps or tables (no. 22; fig. 30). Cicero collected these too, though on one occasion even he balked at the price.

> As for the table-support, which perhaps you intended for yourself, keep it if you like it. If you have changed your mind, though, I'll keep it myself. For the sum involved I would much rather have bought a house at Tarracina, so as not always to be a bother to my host there.
>
> *Letters to his friends* vii.23.3

It would, of course, be misleading to suggest that sculpture in Roman Italy (or elsewhere) was a largely private affair of the cultured elite. Indeed, the vast bulk of all Roman sculpture that survives probably embellished the innumerable public buildings of Roman cities throughout the empire, from gateways to basilicas, baths, libraries, and so on (fig. 31). Whatever and wherever the clientele, the thirst for

FIG. 31.

[15] See A. L. Campbell, *Mithraic Iconography and Ideology* (Leiden, 1968); J. M. C. Toynbee, "Mithras," *Oxford Classical Dictionary* (Oxford, 1970), pp. 694–695.

[16] On Roman deification of the dead in this way, see H. Wrede, *Consecratio in formam deorum* (Mainz, 1981); a study of the Lansdowne Hermes type from this point of view is planned by present author for the near future.

decorating their architecture with reminiscences of the Greek masterpieces was seemingly insatiable.

Of course, the head of the Hermes is not a portrait in any normal sense of the term, so one can never be sure whether this was indeed the statue's function. For Roman portraiture proper in the Santa Barbara collection one must turn to the horse's head (no. 19), presumably broken from some equestrian statue of the early empire (cf. fig. 17), and to the superb late Imperial bronze (no. 21).

In the face of these endless ranks of statuary, repeated over and over again with little variation from one end of the empire to another, traditional divine imagery rapidly lost whatever force it still possessed. Indeed, five centuries of Roman hegemony only produced one new cult statue of any compelling power: the figure of Mithras (no. 31). Brought to Rome from the East at the end of the Republic, this Iranian dualistic cult celebrated the vanquishing of Evil (the bull, symbol of Ahriman) by Good (Mithras, ally of Ahura Mazda). Popular with the Roman army for its intimations of immortality, it swiftly developed into a mystery religion of obscure ritual and complex symbolism.[15] Thus, as Mithras slays the bull, a dog and a snake lap up the life-giving blood, and corn-ears sprout from the beast's tail. The image is compelling and forceful, an apt focus for a cult that for a time posed a serious threat even to Christianity.

This craving for personal immortality also manifested itself in other, even more direct ways. As we have seen, the Lansdowne Hermes (no. 27) could have decorated some aristocrat's private villa; equally, however, it could have stood over his grave. Several other replicas of the same type have been found in such contexts, dating back to the second century B.C. In such cases the deceased is intended not merely to be thought of as heroized, but as actually deified, as coextensive with the god — the ultimate in wish-fulfillment.[16]

Here, however, the dogged self-confidence of its Republican and Flavian models has all but melted away. In its place is more than a tinge of anxiety, the anxiety of a people whose world was inexorably slipping from their grasp. Third-century Rome, ruled by barrack-room emperors, racked by civil war, harrowed by barbarian tribes, and captivated by transcendental creeds like Neo-Platonism and Christianity (nos. 24-25), bore little relation to the tranquil world-state of Augustus or Hadrian. Like the society for which it was made, this head with its schematic structure, grim demeanor, and burning eyes is already, in some respects, pre-mediaeval.

Andrew F. Stewart
Berkeley, September 1982

Color Plates

10.
Draped Apollo Kitharista, detail, marble

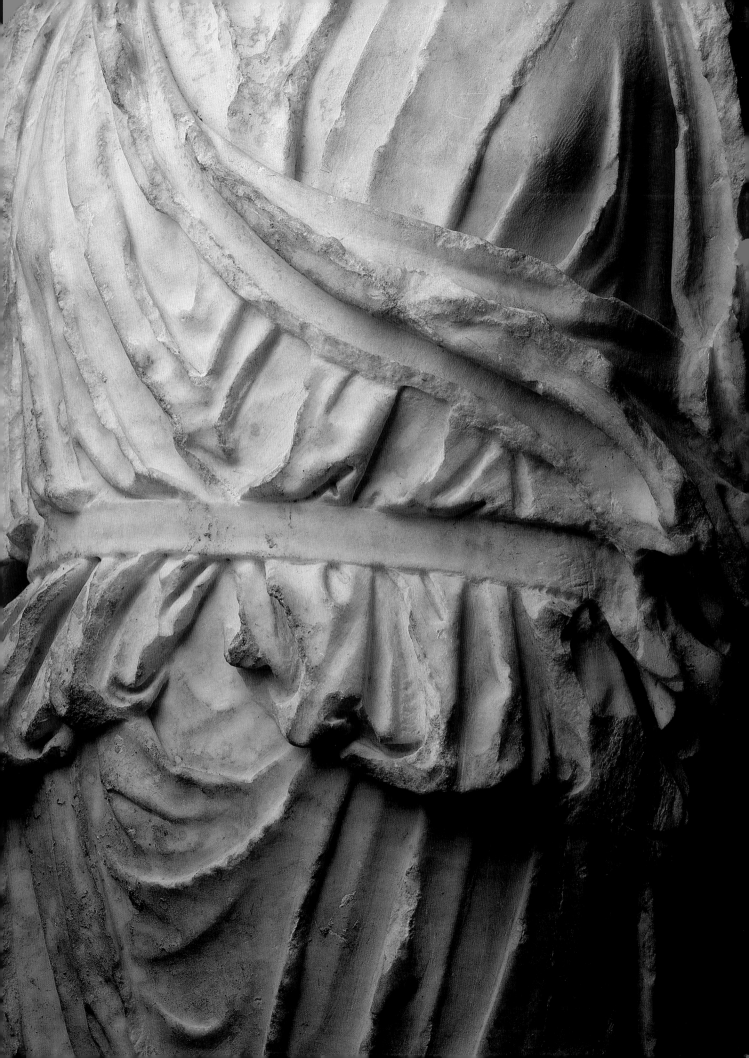

15.
Head of Aphrodite, marble

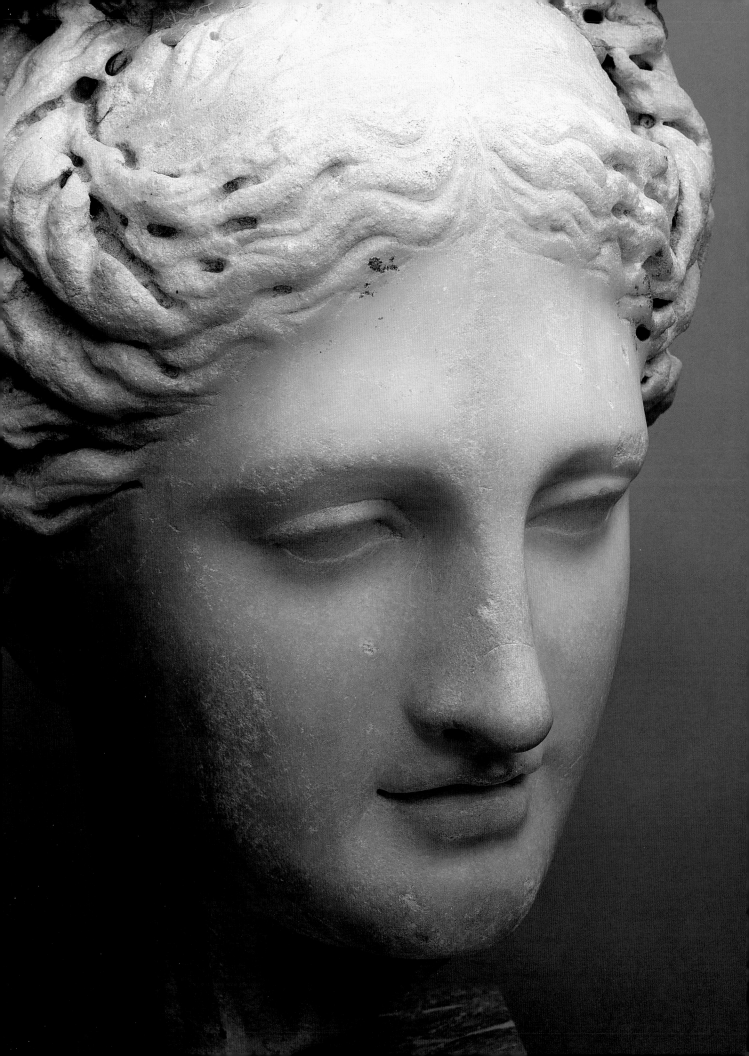

21.
Bearded Head, detail, bronze

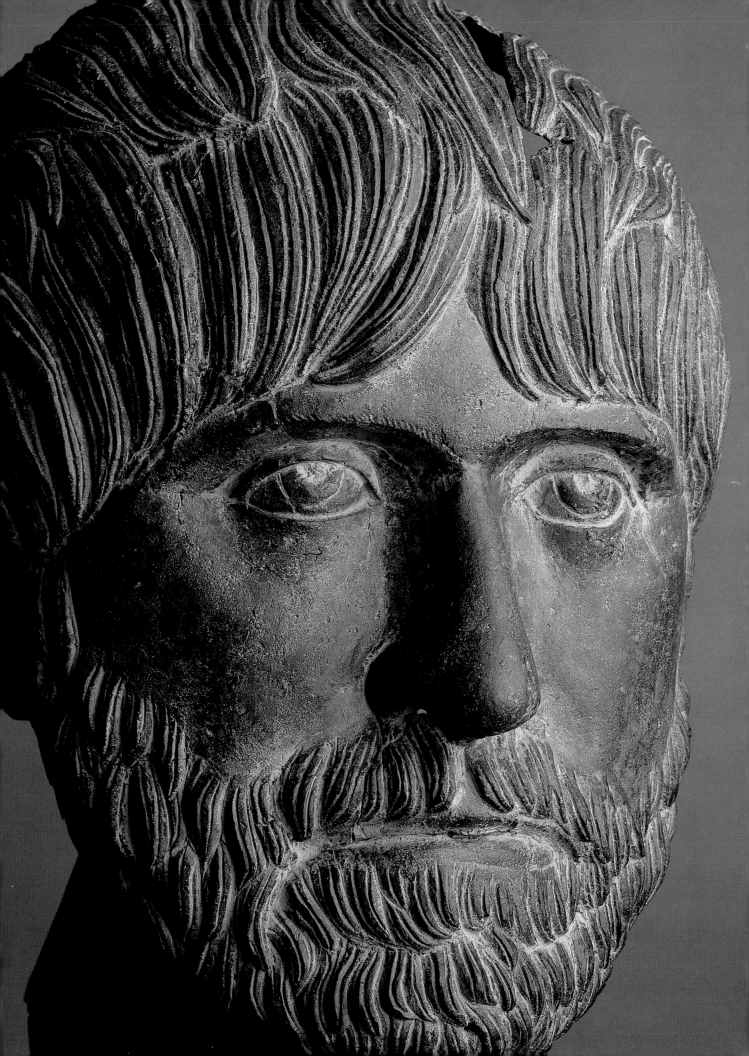

22.
Fragmentary Table Leg (Trapezophoron), detail, marble

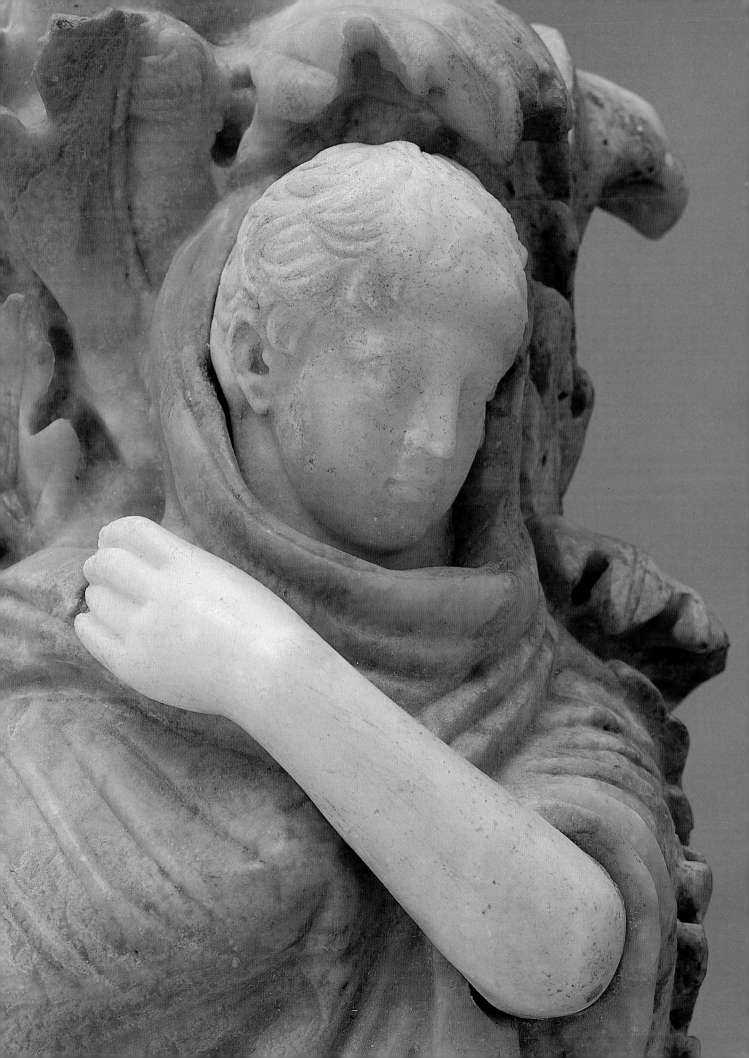

31.
Mithras Sacrificing Bull, detail, marble

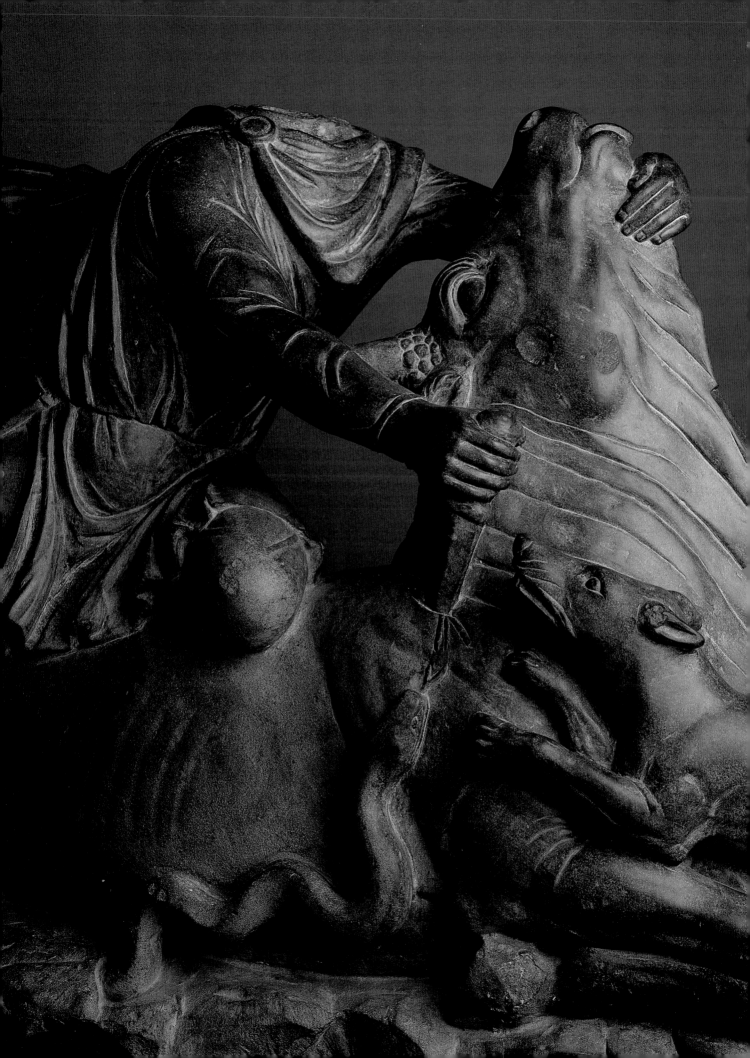

32.
Head of Alexander, bronze

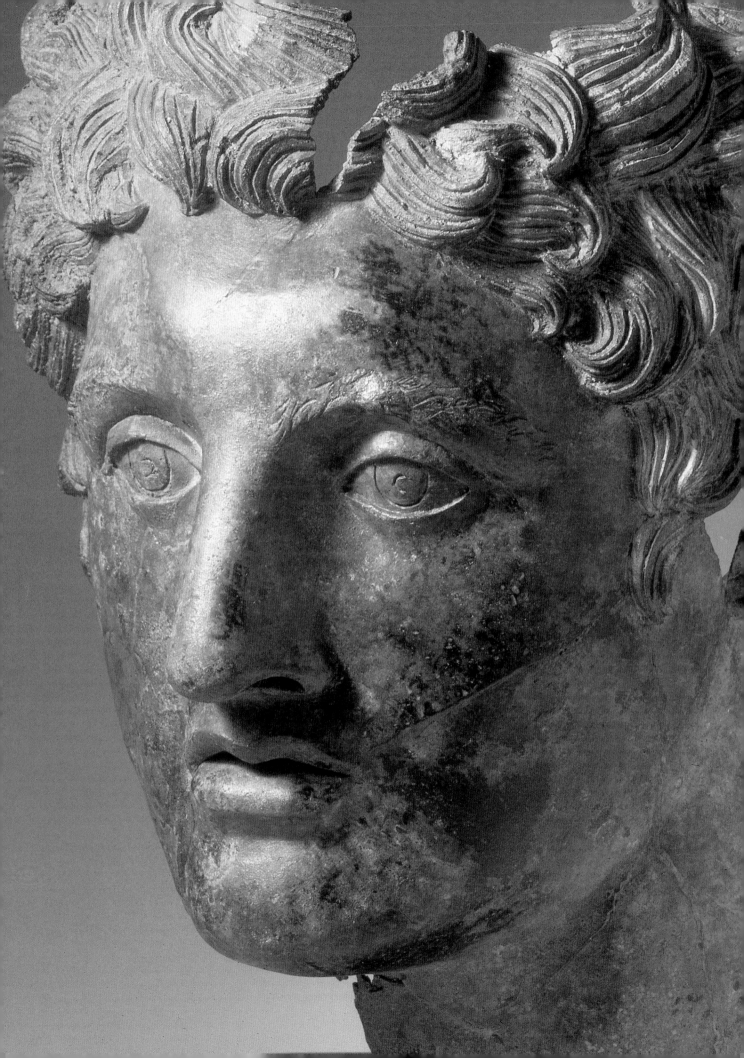

Comparative Figures

Selected Bibliography

The following brief bibliography consists of works on Greek art in general and on Greek sculpture; all are readily accessible standard works in English.

G. Becatti. *The Art of Ancient Greece and Rome.* New York, 1967.

M. Bieber. *Ancient Copies.* New York, 1977.

_____. *The Sculpture of the Hellenistic Age.* Rev. ed. New York, 1961.

J. Boardman. *Greek Art.* London, 1964.

R. Brilliant. *Art of the Ancient Greeks.* New York, 1972.

B. Brown. *Anticlassicism in Greek Sculpture of the Fourth Century B.C.* New York, 1973.

Charbonneaux et al. *Archaic Greek Art.* New York, 1971.

_____. *Classical Greek Art.* New York, 1972.

_____. *Hellenistic Art.* New York, 1973.

R. M. Cook. *Greek Art.* New York, 1972.

C. Havelock. *Hellenistic Art.* Greenwich, Conn., 1971.

R. Holloway. *A View of Greek Art.* Providence, 1973.

R. Lullies and M. Hirmer. *Greek Sculpture.* New York, 1960.

G. Richter. *Archaic Greek Art.* New York, 1949.

_____. *A Handbook of Greek Art.* 6th ed. New York, 1969.

_____. *The Sculpture and Sculptors of the Greeks.* 4th ed., rev. New Haven, 1970. (All references to this work in this catalogue are to the 4th edition, in which the choice and numbering of the illustrative material differ considerably from those of earlier editions.)

B. Ridgway. *Fifth Century Styles in Greek Sculpture.* Princeton, 1981.

_____. *The Severe Style in Greek Sculpture.* Princeton, 1970.

M. Robertson. *History of Greek Art.* Cambridge, 1975.

_____. *A Shorter History of Greek Art.* Cambridge, 1981.

Museum Staff

Administration

Richard V. West
Director
Carl B. Vance
Deputy Director
Shelley S. Ruston
Assistant Director,
Publications and Programs
Gunda Muller-Palm
Executive Secretary
to the Director
Peggy Stevens
Administrative Assistant to
the Deputy Director
Mila J. Good
Programs and Publications Assistant
Susan Kelly-Ledig
Receptionist

Curatorial

Robert Henning, Jr.
Chief Curator
Diane Shamash
Curator of Modern Art
Barry M. Heisler
Assistant Curator of Collections
Merrily Peebles
Assistant Curator for Exhibitions
Susan Shin-tsu Tai*
Assistant Curator for Oriental Art
Richard Hubbard
Designer
Ethel King
Curatorial Assistant
Frances Warr
Curatorial Secretary

Collections Management

Elaine Poulos Dietsch
Registrar
Elaine Cobos
Assistant Registrar
Silvia Tyndall*
Preparator

Education

Penny Knowles
Curator of Education
Ron Crozier
Librarian
Pamela Hoeft
Museum Educator
Lesley King-Wrightson*
Slide Librarian
Frances Thorpe
Education Assistant
Kelly Cretti
Library Assistant

Development and Membership

Wilbur Kenneth Cox
Director of Development
Anne Bomeisler Farrell
Associate Director of Development
Virginia Cochran
Public Relations Director
(Museum Consultant)
Mary McDonald
Membership Coordinator
Kathy O'Leary*
Events and Volunteer Coordinator
Kimberly G. Edgar
Development Secretary
Anita Masi
Public Relations Assistant
Ronna Gordon*
Computer Operator

Business Office

Philip G. Savas
Controller
Willie M. Rowan
Accountant
Clyde Alcorn*
Accounting Clerk

Treasure Sale and Clothes Gallery

Nancye Andriesse
Manager
Katherine Wollman*
Assistant Manager
Letha Lovett*
Assistant Manager
Bud Hammer*
Technician

Bookstore

Penny Mast
Bookstore Manager

Maintenance and Installation

Dean Dawson
Building Superintendent
Jerry Travis
Building Technician I
John A. Coplin
Building Technician I
Eugene Brundin
Building Technician II

Security

Larry Larson
Chief of Security
William Andrews
Deputy Chief of Security
Noel Assayech
Security Control
Guards: David Brown, Walter
Hildbrand, Keith Chandler,*
Jerry Major,* Bradford Wright,*
Ross Andrews,* Karen Kozak,*
David Roby*

*Denotes part-time employment

Glossary

AEGIS - Originally an attribute of the God, Zeus, this goatskin garment was often loaned to other gods, to be worn during battle. Its magical powers caused the wearer to become invulnerable. It was decorated with a Medusa head and fringed with snakes.

APOPTYGMA - The overfolds which appear at the waist of a peplos garment when being worn.

ARCHITRAVE - The horizontal element of a temple structure located above the tops of the columns and below the roof line.

CADUCEUS - The short staff around which intertwine a pair of snakes often carried by Greek ambassadors to signify peaceful intentions. It often appears as an attribute of Hermes or Mercury.

CHITON - A rather long, light linen garment, generally worn by both men and women. It was usually belted and worn over both shoulders.

CHALMYS - A mantle of a short length which was worn over one shoulder. It came to be associated with Hermes, Messenger of the gods as well as with travelers.

GLYPTIC - To cut away a part of the surface in order to leave an image. This technique is especially pertinent to the carving of stones, gems and the production of dies used to make coins.

HIMATION - A rectangular mantle draped over the shoulder and wrapped around the body. It was worn as a cloak by both men and women.

KITHARISTA - The term applied to the representation of the god Apollo as he stands holding a lyre-like musical instrument (kithara) in his left arm.

KOLPI - A general term used to describe the overfolds evident at the waist of a garment when being worn.

KOUROI - (Plural of Kouros) - This term is applied to the representation of male youths, generally shown nude and striding forward.

METOPE - The architectural panel found between triglyphs on an architrave. During the development of Greek architectural style, this became a place for decoration using relief sculpture.

PEPLOS - A female garment worn over both shoulders and belted.

POLIS - The Greek term for "city-state".

TRIGLYPH - The vertically divided architectural elements of an architrave. These developed into a decorated zone, which alternated with the sculpted metopes. Since originally an area where the ends of the roof beams appeared, in all likelihood, this decoration was developed to hide the beams.